digital negatives

DIGITAL NEGATIVES

Using Photoshop to Create Digital Negatives for Silver and Alternative Process Printing

Ron Reeder

Brad Hinkel

ELSEVIER

AMSTERDAM • BOSTON • HEIDELBERG • LONDON • NEW YORK • OXFORD
PARIS • SAN DIEGO • SAN FRANCISCO • SINGAPORE • SYDNEY • TOKYO

Focal Press is an imprint of Elsevier

Acquisitions Editor: Diane Heppner
Project Manager: Dawnmarie Simpson
Marketing Manager: Christine Degon Veroulis
Cover Design: Eric Decicco
Typesetter: Charon Tec Ltd (A Macmillan Company), Chennai, India; www.charontec.com

Focal Press is an imprint of Elsevier
30 Corporate Drive, Suite 400, Burlington, MA 01803, USA
Linacre House, Jordan Hill, Oxford OX2 8DP, UK

∞ Recognizing the importance of preserving what has been written, Elsevier prints its books on acid-free paper whenever possible.

Library of Congress Cataloging-in-Publication Data
Hinkel, Brad.
 Digital negatives : using photoshop to create digital negatives for silver and alternative process printing / Brad Hinkel, Ron Reeder.
 p. cm.
 Includes index.
 ISBN-13: 978-0-240-80854-3 (pbk. : alk. paper)
 ISBN-10: 0-240-80854-1 (pbk. : alk. paper) 1. Photography—Negatives. 2. Photography—Digital techniques. 3. Photography—Printing processes.
4. Adobe Photoshop. I. Reeder, Ron. II. Title.
 TR290.H56 2006
 771′.430285—dc22 2006024409

British Library Cataloguing-in-Publication Data
A catalogue record for this book is available from the British Library.

ISBN 13: 978-0-240-80854-3
ISBN 10: 0-240-80854-1

For information on all Focal Press publications
visit our website at www.books.elsevier.com

06 07 08 09 10 10 9 8 7 6 5 4 3 2 1

Printed in China

Working together to grow
libraries in developing countries

www.elsevier.com | www.bookaid.org | www.sabre.org

ELSEVIER BOOK AID
 International Sabre Foundation

contents

a c k n o w l e d g e m e n t s

Our first thanks go to Dianne Heppner from Focal Press for helping us get this book project started. We are grateful for the opportunity to publish with Focal Press.

We also like to thank Kevin Sullivan at Bostick & Sullivan for his original comments on digital negatives that got Brad excited about this opportunity several years ago – and his general help on a variety of questions around alternative processes. Our thanks go to Roy Harrington for creating the Quadtone RIP that has become so useful for our digital negative workflow. And we wish to thank the Photographic Center Northwest in Seattle where Ron and I met, and where we did many of our experiments on digital negatives. I do hope to see inkjet printers in their darkroom soon.

We would also thank Dawnmarie Simpson and Stephanie Barrett at Focal Press and Maro Vandorou from the Oregon College of Arts & Craft for providing valuable feedback on the book as I developed it.

Brad –
I need to thank my wife, Sangita, for her patience as I redirected my career from software to photography (and back again to software in photography). And finally, I need to acknowledge Raja and Pablo for their late night support during this project. And Mira Nisa and Anjali for teaching me some perspective on what is really important.

Ron –
My wife, Judith, my partner in photography and everything else. She gave me the freedom to spend years printing step tablets as I learned the art of digital negatives.

Thanks to all – Brad Hinkel & Ron Reeder, Aug 2006

digital negatives

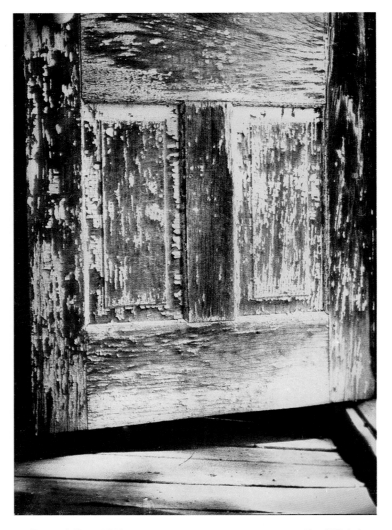

Bannack Door 1999 Brad Hinkel

'Bannack was the first capital of Montana and a major mining town through the turn of the 20th century. This door was the entry to a home that likely made its owner proud. Yet the years have had their toll.'

Daguerreotype

The original was captured with a 4 × 5 view camera onto TMax 100. The exposure time was about five minutes long to maximize the contrast. The images was scanned into Photoshop and edited to maximize the sharp details. I chose to print the final image onto a Daguerreotype to match the period of the original location and make the image as much and artifact as the door. The image was reduced on contrast and a positive was printed onto Pictorico High-Gloss White Film. The positive was contact printed onto the Daguerreotype plate. The Daguerreotype was processed using the Becquerel process.

Final print size, about 3 × 4 inches.

1 introduction

This book describes methods for making digital negatives that rival or exceed negatives made in the conventional wet darkroom. In the history of photography, most methods of printmaking have been contact printing processes, requiring a negative the size of the final print. This has been true for albumen, cyanotypes, platinum/palladium, and many other printing processes. Even for silver/gelatin, where enlargement from a small negative is possible, there are advantages to contact printing from a large negative. In the past, however, a serious drawback to contact printing has been the difficulty of obtaining that big negative. Two approaches were available, neither very appealing:

1. You could lug around a large camera, plus plateholders, and make the big negative in camera. Unless you had one of Ansel's mules, the size of the equipment severely limited your mobility, the choice of subject, and the number of exposures that could be made in camera.

2. You could take a small negative into the wet darkroom and enlarge it. This took time, involved making an interpositive, precise process control, and the near certainty of introducing dust and some image degradation into the final negative.

Figure 1-1 The original portable camera system.

The ability to make high-quality digital negatives has dramatically changed this situation. It is now possible to start from any image, digital or analog, and in a few minutes produce a digital negative whose size is limited only by the size of the available printer. The speed of this process makes it feasible to fine-tune the image to a degree previously unimagined.

In this digital age, a skeptic might ask: why bother with negatives at all? Why not just print the image on some fine art paper, using the latest inkjet printer, and be done with it? As the quality of digital printers continues to improve, it is true that many photographers will find that a digital print is an excellent end point for their images. However, it can be argued that the look and feel of classical printing processes has yet to be equaled, and may never be equaled, by digital prints. There is no question that digital prints can be beautiful. But, just as silver/gelatin prints never really replaced platinum/palladium prints, we think it unlikely that digital printing will completely replace the older printing methods. In fact, current photographers can enjoy the best of both the digital and analog worlds. Many of us, for example, still prefer to capture the original image on fine-grain analog film using a 4 × 5 view camera. This approach affords tremendous control and is still the most cost-effective way to capture and store a high-quality image file. These film negatives are then scanned with a scanner that essentially resolves the grain structure of the film, thus capturing all of the information in the negative. Once digitized, images are worked on in Adobe Photoshop®, which offers a powerful array of tools for maximizing the expressive potential of the image. Finally, the images are printed out as full-size digital negatives with contrast range precisely adjusted to match the requirements of whatever printing method is desired. This approach weds the undeniable power of Photoshop to all the lovely hand-coated printing methods that have been devised throughout photographic history.

We have tried to include in this book everything we know about how to produce the best possible digital negative. At the same time, we would like this information to

be accessible to and user friendly for any photographer with some basic Photoshop experience. These two goals are in some conflict with each other. Though the process of making a digital negative is basically quite simple, there are a lot of details along the road to making a really fine negative. Getting hit with all these details at the very outset can be daunting, and might discourage some photographers from learning a powerful and rewarding skill.

The simplest approach to solving the problem is to follow one of our recipes. If you would like simply to make a decent negative and print, without immediately learning all the whyfors and howsomevers, go straight to either Chapter 4 or 5. In Chapter 5 we tell you what to buy and how to use it to make a digital negative and a very respectable palladium print. In Chapter 4 we tell you the same information to make a negative for exposing a silver/gelatin print. All you have to do is follow the steps verbatim and we can practically guarantee pleasing results.

If you like the prints you made following the recipes, then you might want to learn the reasoning behind each of the steps and how to fine-tune the processes. This information is presented in Chapters 2, 3, 6, and 7.

The core idea behind digital negatives is to measure the density changes caused by your specific photographic printing process and create a custom 'correction curve' tuned to make a perfect print for that process. Learn to make correction curves, and a whole world of photographic process becomes available to you.

In our work, we have used two fundamentally different methods to apply this necessary correction. One method is to make a correction curve in Photoshop, save it as an .acv file, and apply it to an image prior to printing. This is the correction method currently used by most digital negative printers. We use this method in Chapters 4 and 5 to make the basic palladium and silver prints, and we describe the process for creating these correction curves in detail in Chapter 7. We recommend that you start with this first method; it is effective and will help you understand how correction curves work.

Figure 1-2 The photographer as chemist.

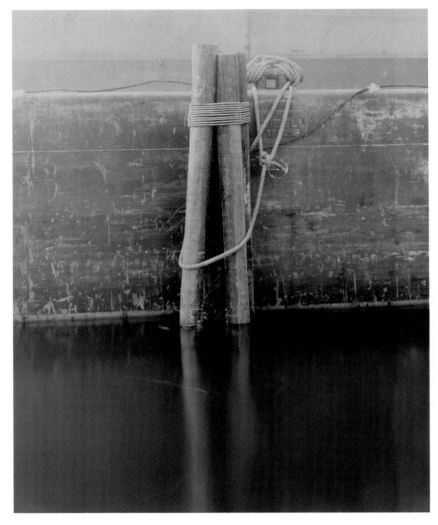

Barge & Piling 2001 Brad Hinkel

'The gentle motion of the water was still able to move this massive barge, albeit slightly. The log piling was the foundation that kept the whole scene steady.'

Chrysotype (gold print)

I captured this image using a 4 × 5 view camera onto TMax 100 film. The exposure was fifteen minutes long to accentuate the slight motion of the barge and soften the waves in the water. I scanning the image into Photoshop to maximize the overall contrast. A negative was printed onto Pictorico OHP film and contact printing onto a chrysotype emulsion on Arches Platine paper. The chrysotype print is very similar to the platinum print except gold is used in place of platinum. This print creates the magenta/blue split tone in the final image.

Final print size, about 4 × 5 inches.

As it turns out, a second, more effective correction method has been available, but only for those with programming skills or expensive printing software. This second method applies the correction in the ink settings of the printer driver, and does not correct or change the image file. Recently, an inexpensive printer driver called the QuadTone RIP has become available that allows ordinary mortals (like us) to control the ink settings and place the necessary corrections in the printer driver. In Chapter 10, we describe how to use the QuadTone RIP for digital negatives, building on techniques described in earlier chapters. We think the QuadTone RIP will cause a minor revolution in digital negative printing.

Digital negatives can be used to print in any photographic process that has ever been invented. Some of these processes we have tried and many we have not. We include a final chapter describing some slightly offbeat uses of digital negatives and speculate on how they could be used in other processes.

This book contains all of the instructions for printing digital negatives, but you will also need a few digital files for the recipes and to create your own correction curves. These can be found on the Web site for this book at www.digital-negatives.com. References to the Web site can be found in various sections of the book.

Figure 1-3 The sophisticated photographer, circa 1890.

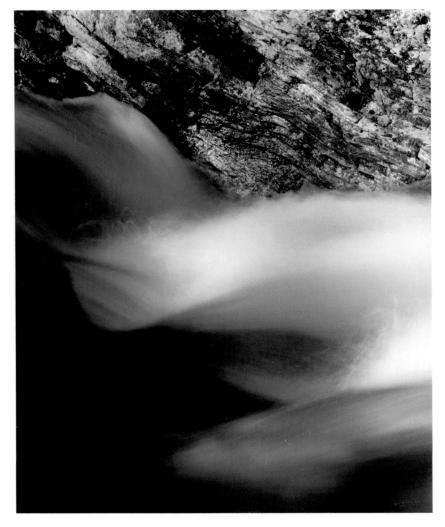

'This small waterfall captured the rocky texture of the mountain rocks, the strong motions of the water and the bright mountain light.'

Platinum/Palladium

I captured this image using a 4 × 5 view camera onto TMax 100 film. I used filters to lengthen the exposure time to one second to ensure the smooth flowing water. The small streaks of water were from bright drops of water moving over the waterfall.
I scanning the image into Photoshop and adjusted the contrast of the rock wall and the waterfall separately so the would each have full contrast. A negative was printed onto Pictorico OHP film and contact printing onto a Platinum/Palladium emulsion on Arches Platine paper. The emulsion had about 80% Palladium to create a rich warm print.

Final print size, about 11 × 14 inches.

Waterfall 1999 Brad Hinkel

2 basics of digital negatives

This chapter provides the theory portion of this book. There really is not much dense theory for digital negatives, so this should not be too big an issue. In our experience some photographers love theory and others just hate it, so some readers might be frustrated. In fact, most of the theory in this chapter applies to basic ideas about photographic materials, so you should become familiar with it.

The basic concepts for digital negatives are

- Photographic processes are nonlinear. The density on a final print is not the same as the inverse of the corresponding density on the negative, but is based on a complex response curve.

- Correction curves can fix the nonlinearity of the photographic process.

- Each photographic process has its own relationship between the negative density and the print density; thus, each photographic process requires its own correction curve.

- Digital negatives are contact printed.

- There are many varied and exciting photographic processes.

At the end of this chapter, we will also provide a basic overview of the whole workflow for printing with digital negatives. Hopefully, this provides a good framework for reading through all of the many steps listed throughout this book.

Photographic Processes are Nonlinear

Ideally, photographic processes would be simple. Forget for a minute that photographic processes are usually negative — the densities in the print are reversed from the negative. It would be ideal if the highlights in the negative mapped directly to similar highlights on the print, and the same for mid-tones and shadows (Figure 2-1).

But photographic processes are not ideal; they are based on real chemistry, and typically produce results that are far from this simple relationship (Figure 2.2).

In fact, most photographic processes produce very nonlinear results. Typically, photographic processes add contrast, making the print highlights brighter and the print shadows darker than the original values.

In our digital negatives model, our goal is to actually try and create a result that is similar to the idealized model. We want the densities in the original computer image to create similar densities on the final print (Figure 2-3).

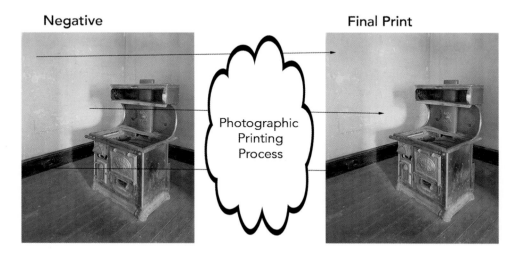

Figure 2-1 Idealized photographic process. With an idealized photographic printing process, the densities in the negative produce similar corresponding densities in the final print.

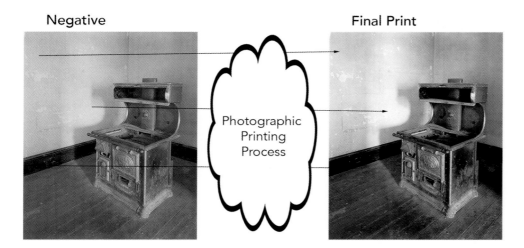

Figure 2-2 Real photographic process. With a real photographic printing process, the densities in the negative can produce vastly different densities in the final print.

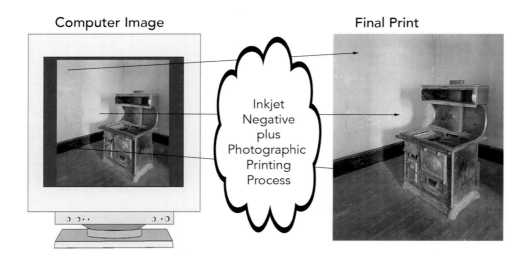

Figure 2-3 Ideal digital printing. Our goal with digital negatives is to have the densities in the computer image create similar densities in the final print.

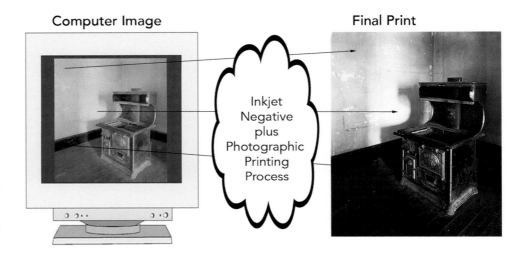

Figure 2-4 Real digital printing. The real process of printing an inkjet negative plus printing using a photographic process can produce results with vastly different densities than the original image.

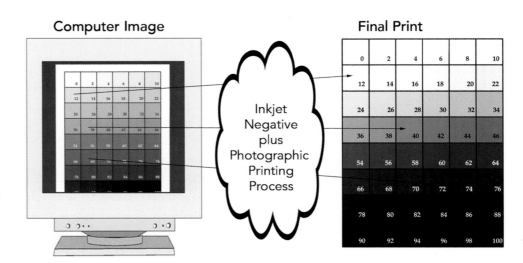

Figure 2-5 Measuring digital printing. The density changes that occur when printing with a digital negative can be measured by using a step table with known densities as the computer image and measuring the final densities in the final print.

But the process of printing a digital negative adds even more variables to the overall process. In particular, the printing of the inkjet negative is not linear as well. So the overall process from the computer image to the final darkroom print usually results in a very different final image (Figure 2-4).

This problem of creating a final print with vastly different densities than the original image is probably the main reason most people give up when they first try printing with digital negatives — often, the results are just ugly.

It is possible to measure the changes that occur as the image is processed from the computer image through to the final print by substituting a step table for the computer image (Figure 2-5).

Using the step table image with known starting densities, it is possible to determine the relationship between the starting densities in the computer image and the densities of the final print.

Table 1 The original densities in Photoshop and the resulting densities on the print after printing via a real photographic process

Computer image density (Input)	Final print density (Output)
0	0
12	2
24	8
40	50
...	...

The density values in the computer are measured as a percentage density from 0 to 100%. The range of densities in the computer is purely virtual — 0% is absolute white to the computer and 100% is absolute black. These virtual values do not really exist in the real world. On the final print, the density values are measured as a percentage from the minimum density (DMin or paper white) to the maximum density (DMax). The minimum and maximum values (and all the values in between) can be

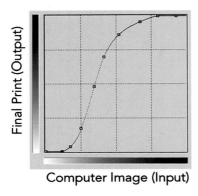

Computer Image (Input)

Figure 2-6 Characteristic curve translates the input densities to the output densities.

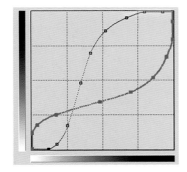

Figure 2-7 Correction curve (in red). The opposite of the characteristic curve, it acts as an undo-characteristic curve.

measured with a densitometer or more simply with a flatbed scanner, but the final print values are still measured as a percentage from 0 (white) to 100% (black).

These input and output values can be plotted to display a characteristic curve for the entire printing process. (Don't worry, you won't have to draw any curves to make digital negatives; but you will make them within Photoshop®.) The characteristic curve shown in Figure 2-6 (Input vs Output) is similar to the Exposure vs Density curves that you may have plotted at one time for analog photographic film. In both cases, going from Input to Output, or from Exposure to Density, the contrast usually increases (the shadows get darker and the highlights get brighter).

Correction Curves

Earlier, we mentioned that the goal of printing with digital negatives is to make the overall system work as an ideal print process. We want the densities in the original computer image to create similar densities on the final print. Correction curves make this work.

Correction curves perform the opposite changes as the characteristic curve. The correction curve acts as an undo-characteristic curve to eliminate the effect of the characteristic curve. The correction curve is simple enough to create because it is merely the opposite of the characteristic curve; merely swap the Input and Output data to create the correction curve (Figure 2-7).

The correction curve is used in Photoshop on the computer image before the image is sent through the digital negative printing process; thus, the image densities are corrected before the printing process changes the densities. The final result is that the printed densities match the original image densities.

We measure the characteristic curve data merely to be able to create a correction curve. The correction curve is the essential piece in creating digital negatives.

Table 2 Data for Characteristic Curve

Computer image densities (Input)		Final print density (Output)
0		0
12		2
24	⟷	8
40		50
…		…
	Swap the curve data	

Table 3 Data for Correction Curve

Computer image densities (Input)	Final print density (Output)
0	0
2	12
8	24
50	40
…	…

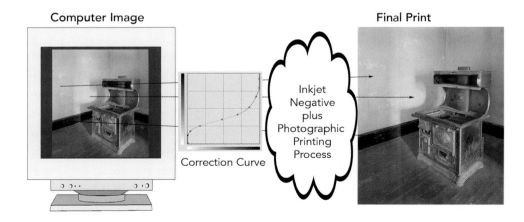

Computer Image

Final Print

Correction Curve

Inkjet Negative plus Photographic Printing Process

Figure 2-8 Printing digital negatives. When printing digital negatives, the correction curve is applied within Photoshop before printing the negative. This corrects for the changes in density caused by the printing process.

Each Photographic Process is Different

There are many different types of photographic processes — silver bromide, platinum/palladium, cyanotype, etc. Each of these processes results in a different characteristic curve and therefore each requires a different correction curve.

In fact, the particularities of your darkroom lead to subtle changes in the characteristic curve for your printing. Changes in your developer, in your specific paper, in the color of light, etc., lead to changes in the characteristic curve. It is important that you create a correction curve for each printing process that you have in your darkroom.

We provide correction curves in Chapters 4 and 5 for the specific recipes described in these chapters (one for silver/gelatin prints and one for platinum/palladium prints). If you can mimic the processes described in these chapters, you will get good prints by using the correction curves that we provide. But changes to the process will cause these curves to work less well. Eventually, you need to learn how to create correction curves for your specific processes.

Many Different Photographic Processes

It often seems that photographic processes are limited to inkjet, silver/gelatin, and possibly platinum/palladium prints, but there are many different types of photographic processes available, including cyanotypes, Daguerreotypes, gum prints, albumin, and so on. You can print with iron, gold, and even uranium. It is important to remember that these processes are available for your final prints.

Most of these photographic processes can only be printed via contact printing — the negative must be the same size as the final print. In the nineteenth century, photographers merely made negatives large enough for their final prints: 8 × 10 cameras

were common. Even in the twentieth century, most of the photographers who used these processes worked with large-format cameras. This led to the notion that these processes were unique or particularly difficult. In fact, many alternative photographic processes are not especially complex; even grade-school children can print basic cyanotypes. With the advent of digital negatives, contact printing has become common again, and you can try out many of these processes.

Even within a specific process, there is significant diversity in how to make the final print. Cyanotypes are often dismissed quickly because they are a bit too cyan, but in reality many different toning options are available to create prints with rich browns or purple tones in the final print. Toning options can increase the number of common photographic options from dozens to hundreds.

Remember, for each particular printing formula, you will need to create a new correction curve.

The Appendix on Resources for Alternative Processes provides more information.

Digital Negatives are Contact Printed

The photographic enlarger changed photography in the early part of the twentieth century. Film could be made smaller and cameras could become fairly portable. The size of the final enlargement was not specifically tied to the size of the original film. This helped revolutionize photography and made it easier for average people to capture their own images.

But the computer can now be used to enlarge images as well. Small images on film can be scanned into the computer, or digital files can be used directly, and each can be enlarged digitally to make large negatives.

This leads to some significant advantages. Contact printing allows you to print with almost any photographic process (so far we haven't found any process that

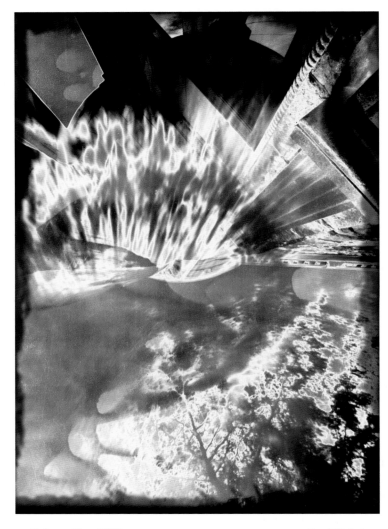

Column Flare 2000 Brad Hinkel

'The flare of the sunlight from the pinhole of this camera overwhelms the image and creates a completely otherworldly image'

Gum Bichromate

The original was captured onto Ilford grade 2 RC paper using a pinhole camera made from the RC paper box. (hey, I like cheap cameras). The box was placed adjacent to a granite building column pointed directly up towards the sun. The flare was the result of the sunlight striking the edge of the pinhole. The original RC paper was developed in diluted RC paper developer (about 20:1) to slow the development time and create some of the wave texture in the print. The image was scanned into Photoshop and adjusted to maximize contrast and accentuate the contrast of the flare. A negative was printed onto Pictorico OHP film and contact printed onto a gum emulsion mixed with orange/brown pigment to make the final print.

Final print size, about 5 × 7 inches.

cannot be printed with a digital negative). Contact prints run little risk of fogging highlights — the dark part of the negative lies directly over the highlight in the final print, protecting it.

Contact prints are also very sharp — the final print is as sharp as the original negative. One common critique of the digital negative is that it is not as sharp as a film negative. This is definitely true. Digital negatives can hold one hundred lines per inch of detail (or even a bit more), but film can hold thousands of lines per inch. This is especially important when trying to enlarge an image using an optical enlarger. But the detail of a digital negative is more than sufficient for making very sharp prints when contact printing. Contact printing makes the use of digital inkjet negatives practical.

The Workflow

You will be presented with our workflow for digital negatives several times in this book. Some essential ideas are included in this workflow, so we will provide an overview here to describe them.

1. Determine a printing process. The specific process that you will use for making your final prints can vary the correction curve significantly, so start by experimenting with your chosen process, and figure out the specific process for how you want to create your final prints. If you have no experience with alternative processes, this may seem excessive as a complete step, but for many photographic processes there may be a rich array of choices to make when determining your specific process: chemistry, toning, papers, etc. Experiment, have fun, try out some variations, and keep good notes of your choice for your final printing process. You will also determine the base exposure for your prints.

2. Create a correction curve. Once you have the details for your specific process, create the correction curve for this process. This is a fairly mechanical step that is performed largely by the numbers rather than based on any specific aesthetics. Follow the steps you wrote down for determining your printing processes. You need to make sure you keep track of your specific printer driver settings so that the steps for printing the negatives are also reproducible. For some users, this is a frustrating, time-consuming step, but with some experience it becomes easy to create correction curves quickly. And once you have a few correction curves available for your favorite processes, you can rely on these for much of your printing. You should also test your correction curves.

3. Create a soft proofing file. The basic model for digital negatives is that the densities of the image within Photoshop are accurately mapped to densities on the final print. But Photoshop typically displays a range of density from monitor white to monitor black (both of which are fairly strong on today's monitors), and the range of densities for many alternative processes can be much different, ranging from an antique paper white to deep sepia black. This difference in density ranges can make the final print appear quite different from the Photoshop image. Some digital negative printers will go back and 'tweak' their correction curves to compensate for this problem, but this subverts the whole notion of a precise correction curve. Create a soft proofing file that will make the Photoshop image appear similar to the final print, adjusting the white and black values. Again, you will just need to create a set of soft proofing files for your favorite processes.

4. Edit your image in Photoshop. Now you get to work on your artistic image. It is essential that you work to make the image look good within Photoshop and not assume anything about how the final print will change the image. Use soft proofing to make the image in Photoshop appear like the final printed image. Save the edited image.

5. Prepare the image file for printing the negative. Follow the specific steps for preparing the file for print. Turn off soft proofing. Flatten the image. Resize the image for the final print size. Apply the correction curve. Flip the image. Invert the image to make it a negative. These are basically quick and easy steps; more on these in Chapters 4 and 5 when you start printing images.

6. Print the digital negative. Make sure you use the same printer settings that were used when making the correction curve and print the digital negative.

7. Print the final print. Finally, go in the darkroom and make your final print, using the digital negative and your chosen printing process. Enjoy the final work.

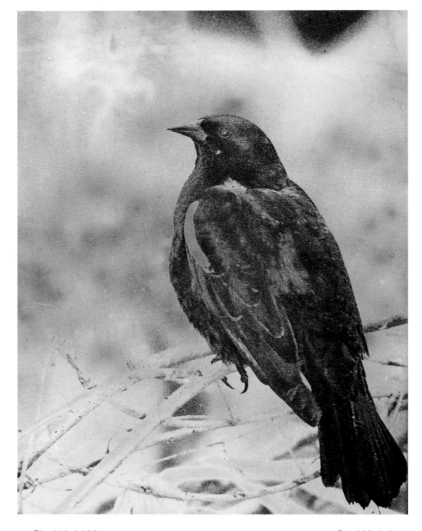

Blackbird 2004 Brad Hinkel

'The red-wing blackbirds in my neighborhood are quite tame; in fact, they act as if they own the place. This one was singing proudly to attract a mate adjacent to the boardwalk.'

Daguerreotype

Captured using a Nikon D1x digital SLR camera using fill flash to add some details to the black feathers. The image was processed in Photoshop to convert it to black & white. The image was reduced on contrast and a positive was printed onto Pictorico Hi-Gloss White Film. The positive was contact printed onto the Daguerreotype plate (the Daguerreotype is a positive process — so a positive is needed to make the contact print). The Daguerreotype was processed using the Becquerel process. I think this is the first example of a digital wildlife Daguerreotype print. Digital negatives should allow use to separate the capture technique from the printing technique.

Final print size, about 3 × 4 inches.

3 capturing the optimal image

Making an optimal digital negative starts with an image file that contains all the important tonal information in the original subject. In practice this means starting with an image file in 16-bit mode that does not clip tonal values in either the highlights or the shadows. With care a good image file can be captured directly using a digital camera or it can be created by scanning a properly exposed and processed film negative. There are advantages and disadvantages to either approach.

This chapter cannot provide all the details for image editing using Photoshop®. We intend to provide some important details for creating digital negatives (lots more information on image editing using Photoshop is available in Brad's book *The Focal Easy Guide to Photoshop CS2* (Focal Press, 2005).

16-bit Mode

One of those annoying digital imaging terms passed about in digital photography is '16-bit mode.' Yet, it is important to have your images use 16-bit mode from capture through to print to ensure the best quality image. This is especially useful in

printing with digital negatives because the printing process for digital negatives can lead to dramatic edits in image density. Even if you do not understand 16-bit mode, use it.

More precisely, 16-bit mode refers to providing 16 bits per channel for storing the density of each pixel in a digital image; it contrasts with the more traditional 8-bit mode for digital images, so that may be a good place to start. Traditionally, computers store numbers in blocks of 8 bits (1 byte). The number stored in these 8 bits could range from 0 through 255, providing 256 discrete values. This is why Photoshop uses values from 0 through 255 to represent densities from black (0) to white (255), with middle grey at 127. For most images, 255 different levels of density are more than sufficient to create a good image. But once we begin to edit the image values heavily, perhaps by adding or removing significant amounts of contrast as will happen with correction curves, these 255 different levels start to be less effective. It would be best if we could have some fractional or intermediate values, so that very fine distinctions in density can be maintained, like a difference between 127.5 and 127.6. The 8-bit mode does not provide this, but the 16-bit mode does. In fact, we like to think of 16-bit mode as merely providing decimal values to track these fractional values for density.

Here is a real example: a moderate field of blue has been expanded to cover densities from bright blue to dark blue (Figure 3-1). A version with 8 bits per channel does not have sufficient precision to display across this entire range of colors, resulting in an image with several discrete values of blue. This is often referred to as posterization. The version with 16 bits per channel has sufficient precision to edit across the full range of colors and display a smooth gradation of colors.

One last point on 16-bit mode. You need to work in 16-bit mode from opening an image through to printing it. A change to 8-bit mode deletes any fractional data values and eliminates the value of using 16-bit mode. This is why it is so important to capture or scan digital images using 16-bit mode.

Original Image & Histogram

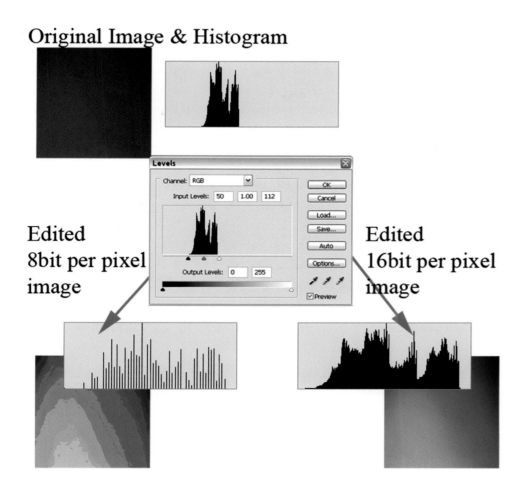

Edited
8bit per pixel
image

Edited
16bit per pixel
image

Figure 3-1 8-bit vs 16-bit.

Capturing an Optimal Image with a Digital Camera

Many digital cameras currently offer the option of photographing in RAW mode, in which all the information captured by the camera's sensor is saved in a RAW file

that can be later accessed by Photoshop without any intermediary processing by the camera itself. This means that you get to make all the decisions about white point balance, brightness, contrast, and other details rather than having the camera make them for you. More important, it makes it possible to capture and keep the image in 16-bit mode throughout subsequent manipulations in Photoshop. For a lot of amateur photography, capturing the image in RAW mode entails more custom work on each image than most people want to do, especially if the aim is just to take happy snaps of the kids on the water slide and send them around to relatives. But, if your goal is to make the best possible digital negative from your image files, shooting in RAW mode allows you to keep loss of tonal information to a minimum as the image is processed.

Processing Camera RAW Image Files

- Read your camera's manual to learn how to set the camera to photograph in RAW mode.

- Download RAW files from your camera to a storage folder on your computer. Your computer will likely not display a thumbnail for RAW file images. You can browse through the downloaded RAW images using the Bridge utility in Photoshop CS2, and then double click on a selected image to open it. When a RAW file opens, Photoshop displays the Adobe Camera RAW window.

- Set the appropriate Workflow Options in Camera RAW (Figure 3-2). In the lower left-hand corner of the window, set Space to Colormatch RGB and Depth to 16 Bits/Channel. Leave the Size option at the default resolution for your camera (if you have a 6-megapixel camera, it will default to 6 megapixels). Resolution can be set at 360 ppi if you intend to print the image on an Epson inkjet printer.

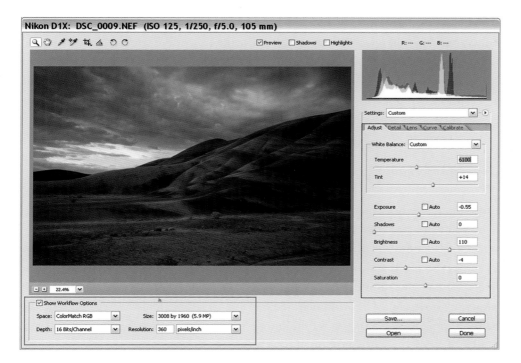

Figure 3-2 Camera RAW Workflow Options.

We use Colormatch RGB for our digital negative images instead of the more traditional sRGB or AdobeRGB color spaces; more on this in Chapter 8, Monitor Soft Proofing.

- Multiple options for editing the image are located on the right-hand side of the Camera RAW window. The default Auto settings on the Adjust tab often work very well, but, if necessary, you can manually move the sliders to globally correct an image's appearance. Fine-tuning of the image is better done later in Photoshop, where layers and other tools are available.

- Once you are satisfied with the general appearance of an image, click Save. A window will open where you can name the image file, select a file format, and select a destination for the saved file. The original RAW file remains unchanged while the modified version is saved in the format you choose. You always have the option of reopening the original, unchanged RAW file and working on it some more.

Converting a Color Image to Black and White

Even though your images may be destined for making black-and-white digital negatives, you will have more flexibility if you capture the original file in full color and convert to black and white once the image is in Photoshop. Photoshop offers several ways to convert to black and white. Two very simple methods are either to desaturate the image (Image > Adjustments > Desaturate) or change to grayscale (Image > Mode > Grayscale). Unfortunately, neither of these methods is very satisfactory because they do not preserve the luminosity of the image. A much better method, even if somewhat more complicated, is as follows:

- Make sure the top layer in your Layers palette is selected and create a new empty layer above it (Layer > New > Layer). In the New Layer window (Figure 3-3), name this layer 'Convert to Black & White' and change its Mode to Color. Click OK to accept this new layer.

- Fill the empty layer with 50% gray. Go to Edit > Fill and select 50% Gray from the Contents Use drop list (Figure 3-4). When the Convert to Black & White layer is filled with 50% gray, the Blending Mode replaces the color of the image with gray, resulting in a black-and-white image (Figure 3-5). The luminosity of the original image is preserved.

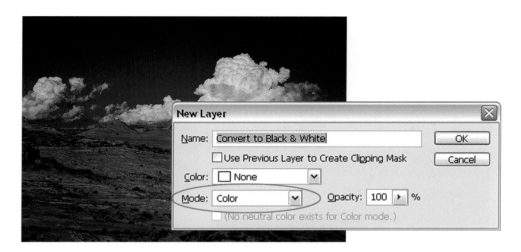

Figure 3-3 Luminosity 1: start.

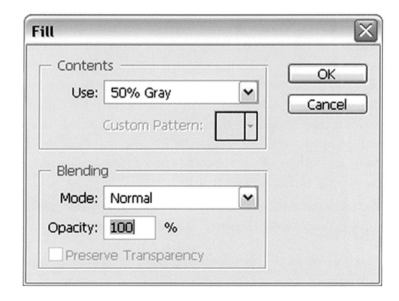

Figure 3-4 Luminosity 2: fill window.

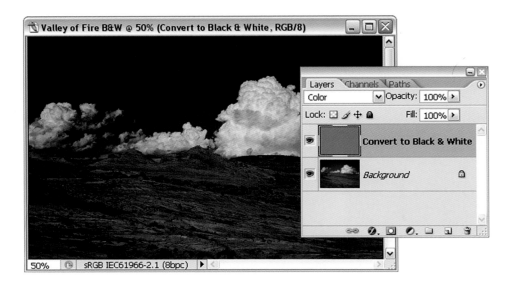

Figure 3-5 Luminosity 3: gray color.

- You can fine-tune the black-and-white image further by playing with the color of the layer below the Convert to Black & White layer. To do this, select the layer below Convert to Black & White and create a new Hue/Saturation adjustment layer (Image > Adjust > Hue/Saturation) (Figure 3-6). Try radical changes in the hue of the color image by moving the Hue slider from side to side. You will see that this causes interesting changes in the tonal relationships of the black-and-white image. Alternatively, you could create a color balance adjustment layer and play with the sliders in that window.

- Once the black-and-white conversion looks satisfactory, flatten the image before proceeding to other image editing.

There are lots of recipes for converting color images into black-and-white images; Google 'convert color into black & white' to find more options.

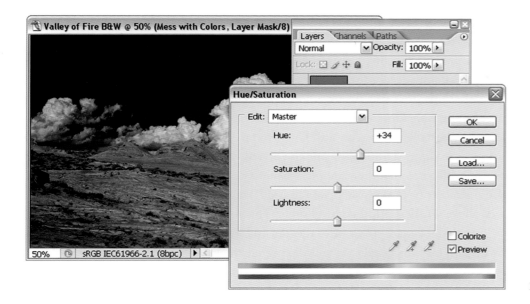

Figure 3-6 Luminosity 4: mess with colors.

Capturing an Optimal Image on Film for Subsequent Scanning

There are still persuasive reasons for capturing the original image on traditional film and then scanning the negative to create a digital file. For example, a 4 × 5 view camera, with the potential for lens and film plane movements and the ability to study the image on the ground glass, is still the tool of choice for many fine-art photographers. In addition, film is still one of the least expensive and most efficient media on which to capture a large amount of image information. A 4 × 5 sheet of film, scanned at a resolution of 2040 ppi in 16-bit depth creates a file of about 150 megabytes. Capturing this much information with any but the most horrendously expensive digital backs is out of the question. It is also worth mentioning that traditional film is by

far the most archival and easily retrievable storage medium for photo files that has yet been invented. You can easily print photos from negatives made by the pioneers of photography over 150 years ago. Compare that to the problems in accessing data stored on floppy disks as little as 10 years ago.

Assuming that you already know how to expose and develop film, the only real problem in using film for the initial capture is getting a good scan of the resultant negative. Perhaps the best way to scan film is to take it to a professional and have it drum scanned. In drum scanning, the film is covered with oil and mounted to the surface of a glass cylinder so that the scanning machinery can be precisely focused on it. A good drum scanner has the sensitivity to record changes in film density ranging from 0 to well above 4 OD (optical density) units. This means that a drum scanner will essentially record the grain structure of the film and will not clip either the densest shadows or the brightest highlights. It will digitize all the information captured by the film. Aside from the cost, the main problem with drum scanning is the inconvenience of having to take the film to the service bureau and retrieve it, plus the scans afterwards.

Ideally it would be nice to have one's own drum scanner sitting on the bench alongside the computer and printer; for those with large toy budgets, Imacon scanners have made that a feasible goal. Imacon scanners do not use oil mounting, but achieve precise film positioning by holding the film in a magnetic blanket, which is then bent into a pre-determined arc. Sensitivity varies among Imacons, with older models operating over a range of 0 to about 3.5 OD units and newer models being able to record information well above 4.0 OD units. In practice, Imacon scans appear to be quite acceptable substitutes for drum scans.

If your budget does not extend into the Imacon range, do not despair of having a workable film scanner on your desktop. The current crop of consumer flatbed film scanners are relatively inexpensive and offer resolution and sharpness that is more than adequate for scanning 4 × 5 film. Probably you will find they are sufficient for medium format as well. Most of them have the option of scanning black-and-white

images in 16-bit depth. The main problem with inexpensive flatbed film scanners is their lack of dynamic range. Despite the manufacturer's optimistic claims, they generally are unable to detect tonal changes in densities above about 2.5 OD units. (Scan a Stouffer step wedge that covers the density range from 0 to 3.0 OD units and see where the scanner fails to see density differences.) This inability to read higher densities is a real problem if you want to generate negatives both for digital scanning and for silver/gelatin printing in the wet darkroom. A well-exposed and developed negative for silver/gelatin printing can have its highlights clipped by one of these flatbed scanners. However, if your primary goal is to produce film negatives for the digital darkroom, there is an elegant solution to the problem. Expose the film so there is adequate detail in the shadows, but scale back development so that the highlights do not become denser than the scanner's ability to read. In Zone System parlance, this means placing shadows with detail on about Zone IV and giving the film N or N-1 development. In essence, this approach takes advantage of the fact that traditional film can capture information over a tremendous range of luminosities. Slight underdevelopment then compresses this information into a density range that a flatbed film scanner can measure.

Scanning a Black-and-White Negative

- Prescan the negative.
- Now turn off every automatic function you can find. You do not want the scanner to automatically set the black and white end points, sharpen the image, adjust contrast, or do anything at all, except scan the image.
- Set the scanner to scan in 16-bit depth (you do not want 16-bit HDR if this mode is offered).

- Choose the highest machine resolution offered. Scanners often offer higher resolutions in which the machine actually scans at a lower resolution and then makes guesses to fill in the gaps and pump up the apparent resolution. Usually, the manual will tell you what the highest machine resolution is. If you need to upsize an image, it is much better to do so later in Photoshop.
- Use the marquee tool to select only the area of the negative.
- **Find and open the histogram.** Set the black-and-white sliders so that they include just the pixels in the image. Leave the middle slider alone (it should be set on 0). Setting the sliders ensures that you will record all the tonal information in the negative and not clip either the highlights or the shadows.
- Hit scan and save the resultant file for editing in Photoshop.

Whether the image is captured with a digital camera or on traditional film, the goal is to end up with a 16-bit file in which neither the highlights nor shadow have been clipped. All further editing of the image can then be done in Photoshop.

You can find a .pdf file called 'About Scanning Film' with specific details on software settings for scanning at www.digital-negatives.com.

Basic Edits in Photoshop

This section provides a very basic introduction to some basic edits that you will likely want to perform on your images before attempting to create digital negatives for printing. These basic edits are in many ways the most important, but Photoshop provides a huge array of additional options for extremely complex and detailed edits. The full range of Photoshop image editing is beyond the scope of this chapter (and beyond the scope of any single book), but here is a start.

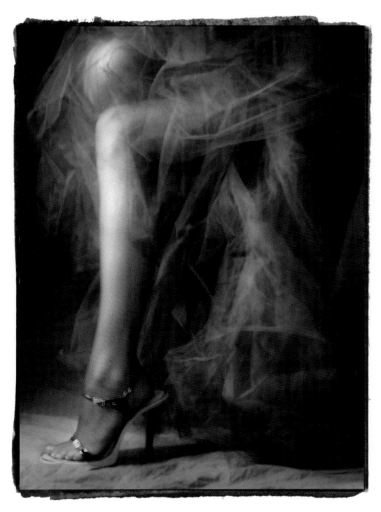

Kate's Legs 2005 Judith Roan

'Slight blur from a hand held camera adds to the sensousness of the image.'

Palladium

Photographed with a hand held digital camera (Nikon D70) using available light. The RGB image file was converted to grayscale, a mild correction curve was applied, the image was inverted and printed as a negative on Pictorico OHP using an Epson 4000 printer and the Quadtone RIP driver. For this image most of the tonal correction was done in the driver using a custom QTR profile. The image was printed on a pure palladium emulsion coated on Arches Platine paper.

Final image size, about 15 × 18 inches.

The basic edits that you should try for any image are

- Black and white point adjustment
- Brightness adjustment
- Contrast adjustment

Black and White Point Adjustment

Most images look best printed to maximum contrast: full black to full white (or perhaps nearly black to nearly white to preserve detail). The first step for adjusting global image density is to ensure the image is adjusted to this maximum contrast.

Access the Levels tool (Figure 3-7) by selecting Image > Adjustments > Levels or, even better, create a levels adjustment layer called 'B&W Point' if you have some experience with adjustment layers.

Moving the black point slider to the right until it is under the first few darkest pixels in the image makes these pixels pure black; moving the white point slider to the left until it is under the first few brightest pixels makes these pixels pure white. Many images need only a small amount of black and white point adjustment. This can be the most effective adjustment you perform.

Brightness Adjustment

The Levels adjustment tool provides an easy way to adjust the overall brightness of an image, and it does it without necessarily adjusting white or black point values. To make a brightness adjustment, open the Levels adjustment window (Figure 3-7), and slide the center gray slider under the histogram.

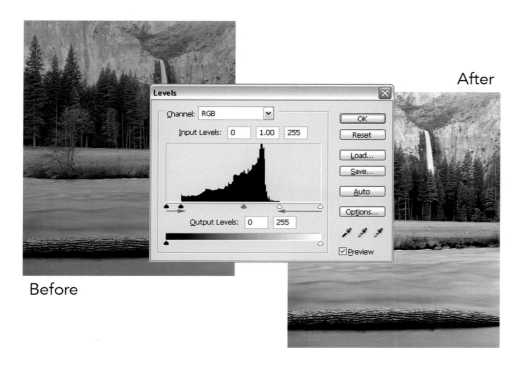

After

Before

Figure 3-7 Basic adjustments: black and white points.

Access the Levels tool (Figure 3-8) again by selecting Image > Adjustments > Levels or, even better, create a levels adjustment layer called 'Brightness.'

Contrast Adjustment

The Curves tool provides a good way to adjust global image contrast. It allows for increased contrast in localized image tones (e.g., the midtones). Increased contrast in the midtones flattens the highlights and shadows, resulting in a global increase in image contrast.

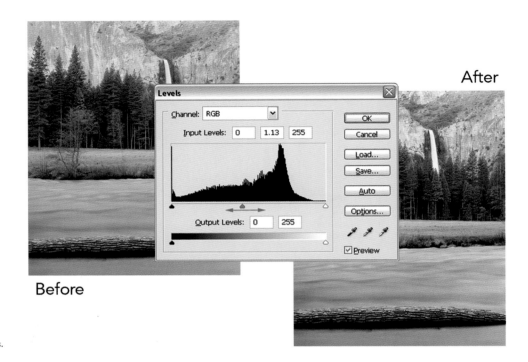

After

Before

Figure 3-8 Basic adjustments: brightness.

Access the Curves tool (Figure 3-9) by selecting Image > Adjustments > Curves or, even better, create a curves adjustment layer called 'Contrast.'

In the Curves window, place a point near the shadow end of the curve and drag it down to decrease contrast in the shadows. Then place a point near the highlight end of the curve and drag it up. Last, place a point near the midtone and adjust it for best global tone. This produces a typical S-curve.

An inverse S-curve produces a flattening of overall image contrast.

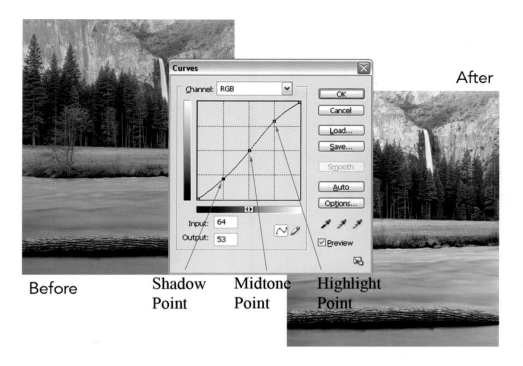

Before

Shadow
Point

Midtone
Point

Highlight
Point

After

Figure 3-9 Basic adjustments: contrast.

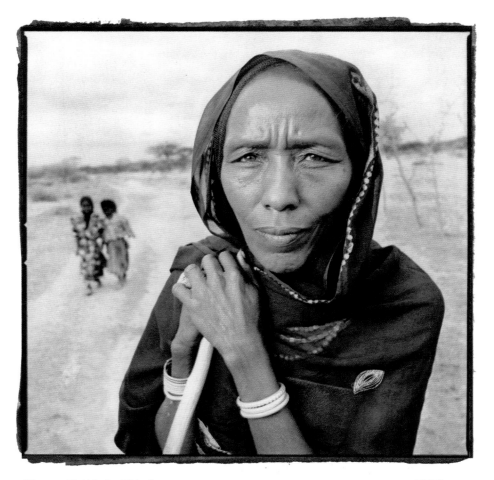

Gilo age 50, Yabelo, Ethiopia Phil Borges

'Gilo is walking her daughter (in the background) to a school recently opened by CARE. Her daughter is the first person in her family to be able to attend school.'

Pigmented Palladium

The image was captured with a Hasselblad camera on Kodak Tri-X film and scanned with a Flextight 343 (Imacon) scanner. The image file was changed from grayscale to RGB mode and areas of skin tone were selectively colored sepia. The RGB image was then changed to CMYK mode and the color channels (CMY) were printed onto a sheet of Arches Platine paper using an Epson 2200 printer. The printed paper was then coated with sensitized platinum/palladium solution and set aside to dry. The black (K) channel was converted to grayscale, a correction curve was applied, and the grayscale image was inverted and printed as a negative on Pictorico OHP. The digital negative was then registered with the coated paper, exposed to UV light, and processed.

Size of the final print, about 18 × 18 inches.

4 a basic workflow for silver printing

This chapter describes the process we use to make a traditional silver print from a digital negative. We present our process here in a step-by-step recipe for you to follow. The recipe has three basic stages: preparing the image in Photoshop®, printing the negative on a desktop printer, and printing the silver image in the darkroom. We have taught this process to hundreds of students and most find that they make a pleasing print on the first try.

The essential element of this process is the correction curve. We provide a correction curve for our specific process using the Epson 2200 printer, Matte Black ink, Photoshop CS2, Pictorico High-Gloss White Film, and Ilford Ilfobrom Grade 2 paper. For the best results, you should try to mimic our process as closely as possible. We have tried to select materials that simplify the process where possible. (If you are unable to mimic our process exactly, don't give up; just give the process a try, knowing that your final print might not be precisely calibrated.) This recipe is designed to give you a taste of how to make silver images from a digital negative. Eventually, you will want to create your own correction curves, as outlined in Chapter 7.

Box 4.1 Correction Curves

Correction curves for this process are available on the Web site: www.digital-negatives.com. This chapter describes the process using the Epson 2200, but additional curves are available for the Epson R2400, the Epson 4000, and other printers. Each curve is bundled in a .zip file containing specific instructions for using the curve.

Box 4.2 Materials Needed to Make an 8 × 10-inch Silver Print

For preparing the image

- A computer with a calibrated monitor
- Photoshop 7.0, CS or CS2
- An image that has been adjusted to look good on your computer screen
- A correction curve for the specific silver process: 2200-UCmk-Gloss-AG.acv (available on the Web site: www.digital-negatives.com)

For printing the negative

- An inkjet printer (we'll use the Epson 2200 for this example)
- Pictorico High-Gloss White Film, letter size

For printing the silver print

- Ilford Galerie Glossy FB Graded #2 paper, 8 × 10-inch
- A contact print frame
- A light source

For developing the silver print

- Four photo trays, 11 × 14-inch tray
- Ilford developer
- A standard fix

Preparing the Image

An essential idea to printing images with digital negatives is that all of the imaging tuning work should happen in the computer. You will not get to do any burning or dodging in the darkroom, printing onto the silver paper is a fairly mechanical process. In order to edit images well on your computer screen, you will need to have a properly calibrated computer. The steps for calibrating your computer are outlined in Chapter 8.

The basic steps for preparing the image for printing the digital negative are quick and easy.

1. Edit. Open a positive, grayscale image in Photoshop and edit it until it looks as you want it on the computer screen. Some further details on image editing are provided in Chapter 3, Capturing the Optimal Image.

2. Duplicate the image. The steps for preparing the image are destructive and are best performed on a flattened image. You should duplicate the image so as not to apply these changes to your original edited file. Select Image > Duplicate…; in the Image Duplicate window (Figure 4-1), change the name to 'My Image Negative.' Check the box Duplicate Merged Layers Only to flatten the duplicate image.

3. Resize the image. The image should be resized for your target print size and the appropriate resolution for your printer. Select Image > Image Size. In the

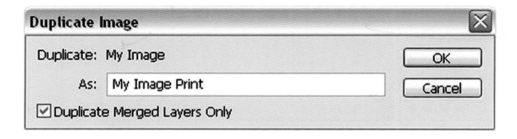

Figure 4-1 Duplicate Image window.

Image Size window (Figure 4-2), change the Width or Height settings to make the image about 8 × 10 inches or smaller; Photoshop automatically changes the other value to ensure that the image retains its proportions. Also, change the Resolution to 360 ppi. Almost all printers print at 300 ppi, but Epson printers print best at 360. Click OK to resize.

4. Apply the correction curve. The correction curve for printing negatives for silver printing using the Epson 2200 is available as 2200-UCmk-Gloss-Ag.acv on the Web site: www.digital-negatives.com. Additional correction curves are available for other printer models. Download the .zip file containing the correction curve and move the curve file into a folder to hold all your correction curves.

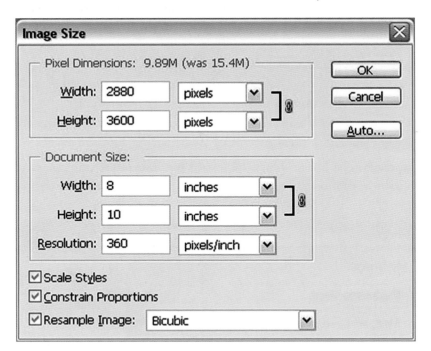

Figure 4-2 Image Size window.

In Photoshop, open the Curves window (Image > Adjustments > Curves). Click the Load button. This opens a Load window (Figure 4-3). Search for your correction curves folder, select the appropriate curve film, and load it.

5. The curve file will make your image appear flat by reducing the contrast of the image (Figure 4-4).

6. Invert and flip the image. You will be printing a negative, so the image needs to be inverted. Go to Image > Adjustments > Invert. The printed negative will be placed face down on the silver paper to print; this flips the image left-to-right. So the negative should be flipped once in the computer to ensure the final image has the original orientation. Go to Image > Rotate Canvas > Flip Canvas Horizontal.

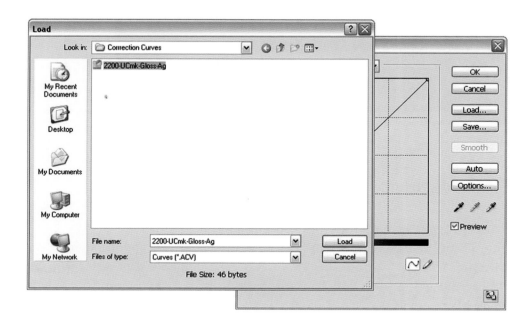

Figure 4-3 Load a curve.

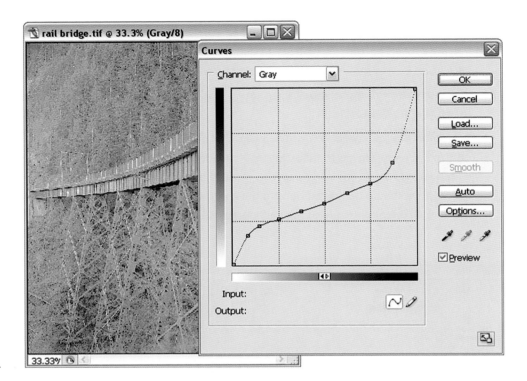

Figure 4-4 The Curve adjustment.

Printing the Negative on the Epson 2200

The steps in this section provide the precise instructions for printing a digital negative onto Pictorico High-Gloss White Film using the Epson 2200 printer running on Microsoft Windows® XP. Since the instructions for printing are identical for both the White Film and for the OHP Transparency Film, we provide printing instructions Apple Macintosh® OSX 10.4 in the section Printing the Negative in Chapter 5.

1. Adjust the printer in-feed to accommodate media 8½ inches wide and slide in a sheet of 8½ × 11-inch Pictorico High-Gloss White Film, printable side up (there should be a notch in the upper right corner when the printable side is facing you). Make sure that your printer has the matte black ink cartridge installed (rather than the photo black). This was the ink we used when creating the correction curve.

2. In Photoshop, with the negative image open, open the Print Setup window (File > Print Setup). Click the Printer button to open the Page Setup window (Figure 4-5). Select the printer from the Name drop list (Epson Stylus Photo 2200) and click OK to return to the main window.

 In the main Page Setup window, select the letter (8½ × 11 inch) paper size, the sheet paper source, and the correct paper orientation (vertical or horizontal). Click OK to close the window.

3. Now open the Print with Preview window (File > Print with Preview) (Figure 4-6). On the left, you will see the negative image positioned on an 8½ × 11-inch page. This is a reality check. If image size or orientation is not correct, go back to the Image Size or Page Setup window and correct them. On the lower left-hand side of the Print with Preview window is a drop box that has two options: Output and Color Management. Select Color Management from the drop list. Further down, in the Options box, set Color Handling to No Color Management. (We discuss the reasons for these settings in Chapter 9, About Printers.) At the top right-hand corner of the Print with Preview window, click Print.

4. In the Print window, make sure that Epson 2200 is the selected printer (Figure 4-7A). Click the Properties button to access the Epson Stylus Photo 2200 Properties window (Figure 4-7B). In the Properties window, click the Advanced button to access the advanced properties settings.

 Figure 4-8 shows the Advanced Properties settings for the Epson 2200. Under Paper & Quality Options, choose a media type from the first drop list. In the

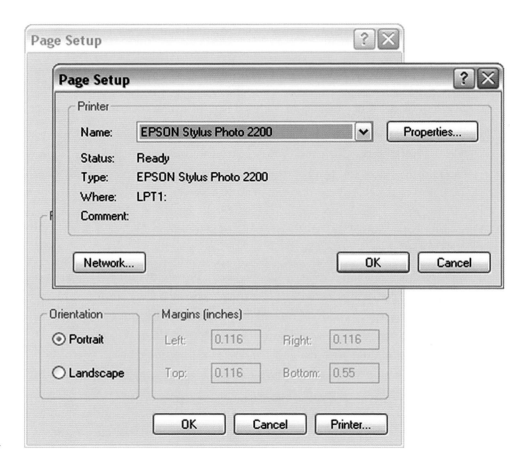

Figure 4-5 Page Setup window.

next drop box, you will not see Pictorico White High-Gloss White Film as an option, so choose Enhanced Matte Paper, which was the media setting used when constructing the 2200-UCmk-Gloss-Ag.acv correction curve. (More on media settings in Chapter 9.) In the next drop box, set Print Quality to

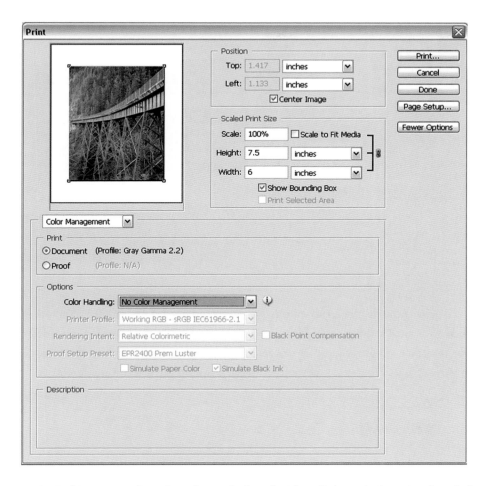

Figure 4-6 Print with Preview window.

Superfine 2880 dpi. On the right-hand side of the window in the Color Management group box, select ICM, and set the ICC Profile to No Color Adjustment. Click OK to return to the Print window and click Print to print the negative.

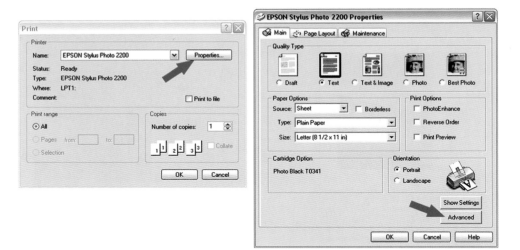

Figure 4-7 (A) Print window. (B) EPSON Stylus Photo 2200 Properties window, Advanced button.

If getting the printer setup sounds confusing and needlessly complex, that is because it is. The essential settings are hidden among so many layers that it is easy to overlook one. However, there is a basic logic to this setup madness and the following checklist, along with reference to the screen grabs in this chapter, should get you through the maze.

Printer Setup Checklist

1. Choose the printer. Do this in the Page Setup window and check it again in the Print window.

2. Check that you have the correct ink installed. For Epson printers this is typically a choice between matte black and photo black. It is important to use the same ink as was used when the original correction curve was created.

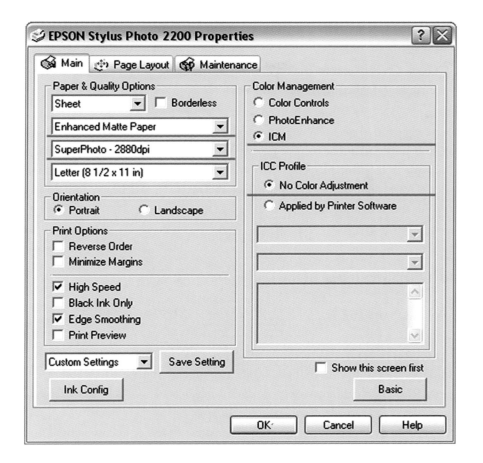

Figure 4-8 EPSON Stylus Photo 2200
Properties, advanced printer settings.

3. Check that you have correctly sized and oriented the image (check this in the
 Print with Preview window).

4. Turn off Printer Color Management in two places: the Print with Preview win-
 dow and under Color Management in the Print window.

5. Select the correct print media in the Print window. It is important to use the same media setting originally used when deriving the correction curve.

6. Choose Quality rather than High Speed printing and select the highest dpi printing mode the printer will support.

A newly printed negative will need to be completely dry before using it to print an image. It is essential that the ink be dry for the negative to have the expected densities and for it to print properly. We often hurry the process with 60 seconds or so under a warm hair dryer. The surface of the negative is delicate. Protect it from fingerprints and abrasion.

Printing the Silver Image in the Darkroom

Exposing the Photo Paper

Silver emulsion paper is sensitive to blue and green light; and it is very sensitive. Any exposure to a traditional visible light source can quickly fog the paper and give you a final print with gray highlights, or more commonly, just solid black. You need to work in a room that can be made completely black.

Typical silver emulsion papers are not sensitive to red or yellow light. Thus you can use a darkroom safelight that provides dim red/yellow light, but allows you to see as you work. Some simple darkroom safelight bulbs merely replace traditional tungsten bulbs in a screw-in fixture. (Don't try to buy just a yellow light bulb as it will likely still expose your paper; you really should buy a safelight bulb.)

For this recipe, you will use graded Ilford Ilfobrom paper that prints at the same contrast (grade 2) regardless of the color of light used to expose the paper.

This makes it easier to use just about any light source to expose the paper. (See Chapter 6 for more on visible light sources.) This recipe will work adequately for most grade 2 papers.

Silver emulsions are also generally very fast; this means they are very sensitive to light and expose quickly. But the High-Gloss White Film on which we print our silver negatives is very dense and reduces the amount of light hitting the photo paper. Typical exposure times using an enlarger as a light source can easily be 2–5 minutes. Using a bare light bulb the times can still be 10–20 seconds. If your exposure times are shorter than about 30 seconds, you may wish to plug your light source into a darkroom timer (Figure 4-9), but we have made numerous prints using our hands on the switch as a timer.

Your exposure light will likely not be the same as the light sources that we used for creating the original curves and test data for these printing steps. Therefore you will need to determine the specific base exposure for your light source and the Ilford Ilfobrom paper. The base exposure is the minimum exposure to print to maximum black, or DMax, through the white glossy film. The steps for determining the base exposure are included in Chapter 6, Exposure.

To expose your silver paper:

1. Keep the silver paper inside the protective box until it is needed, and then remove only one sheet at a time. Keep the box closed.

2. Place your contact print frame under your light source. Adjust the light source to ensure that the entire contact print frame will be exposed by light.

3. Set up your developer, fix, and washing trays as described in the next section, Processing the Print, so that you can immediately develop the print after exposure.

4. Turn off any normal light in the room and turn off the light source. Turn on the safelight if you have one.

Figure 4-9 Darkroom timer.

5. Remove one sheet of silver paper. The emulsion is typically faced up in the box, and it will have a slightly tacky feel. Place the printed negative face down over the silver paper so that the printed side is touching the silver emulsion. Contact printing is typically done emulsion to emulsion to ensure the prints will be as sharp as possible.

6. Place the negative and silver paper into the contact printing frame so that the negative is contacting the glass of the frame and the silver paper is lying such that the emulsion is facing the negative.

7. Place the contact printing frame under the light source.

8. Turn on the light source for the duration of the base exposure.

9. Carefully remove the silver paper from the contact frame and proceed to the next section to develop it.

Processing the Print

Setting Up the Developing Trays

Arrange four photo trays in a row in your darkroom (Figure 4-10). It is convenient to have a shallow sink large enough to hold all four trays because chemicals tend to get splashed about during the development process. But, lacking a large sink, any flat surface with old newspaper to catch the drips will also work.

- Into the first tray pour one liter of developer, diluted according to the instructions on the bottle.

- Into the second tray pour one liter of water and add 10 milliliters of glacial acetic acid. Glacial acetic acid is undiluted, 100% acetic acid and this is the most economical way buy the acid if you do a lot of developing. You can also

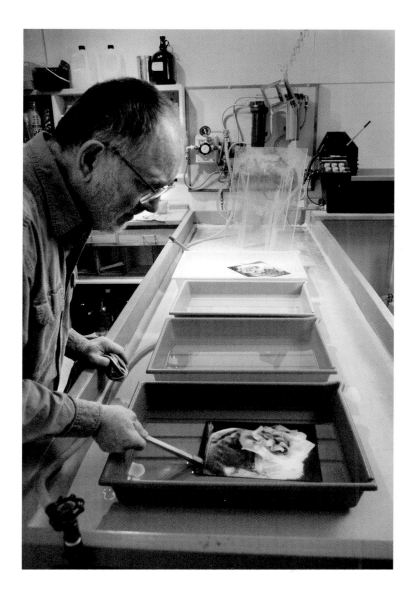

Figure 4-10 Developer.

buy it as a 28% dilution, in which case add 30 milliliters of acid to each liter of water.

- In the third tray pour one liter of fixer.
- In the fourth tray pour several liters of water.

Developing the Print

With room lights off and the safelight on, slide an exposed print into the developer and begin timing. You want to develop long enough for maximum black to form, but not much longer. Give the print continuous, gentle agitation throughout development (just poking at it doesn't count). Usually development takes 1 minute at room temperature for RC (resin-coated) papers, and between 2 and 3 minutes for fiber papers. Do not try to develop the print by inspection under the safelight. The safelight light is dim and it is nearly impossible to judge print quality by its light. After a set development time pull the print from the developer, hold it for 15–20 seconds to drain (Figure 4-11), and slide it into the stop bath. After 30–60 seconds in the stop bath, drain the print, and slide it into the fixer (Figure 4-12). Leave the print in the fixer, with occasional agitation, for at least 1 minute before turning on the room lights. After evaluating the print, you will need to return it to the fixer for about 5 minutes to fix completely, after which you will place it in the final tray, which is a plain-water holding bath.

Viewing and Evaluating the Wet Print

It is difficult to evaluate a newly processed wet print because it will look different once it has been washed and dried. The first problem is that while processing the print you have been standing in a very dimly lit room and your pupils have enlarged quite a bit.

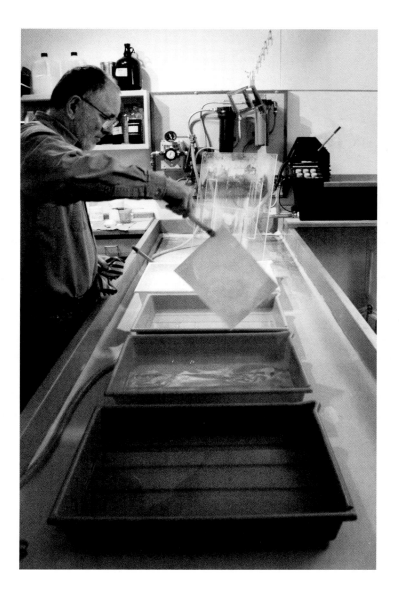

Figure 4-11 Draining.

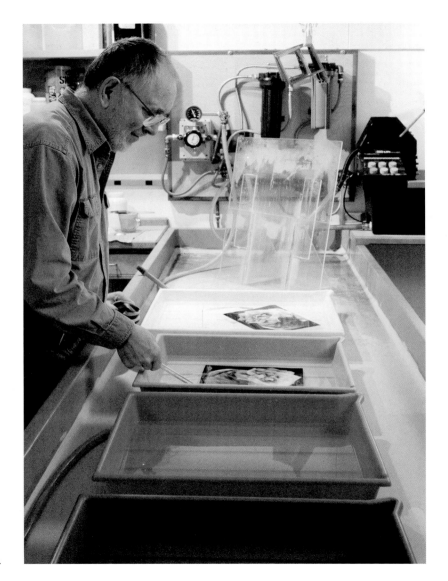

Figure 4-12 In the fixer.

a basic workflow for silver printing

When you turn on the bright room lights, it takes a while for your eyes to adjust, and during that period a print will look brighter than it really is. To compensate for this problem, many printers have a special, low-wattage viewing light in the darkroom that they turn on only to evaluate a newly processed print. A single 40–60 watt bulb, placed high and over your shoulder, is about right. If the newly processed print looks bright and snappy under this viewing light, it will probably also look good under normal room light after it has dried down.

A second problem is that a silver print looks rather different when it is under water than when it is dry. To solve that problem, stand a sheet of plastic up in the sink, slap the wet print onto it (Figure 4-13), and gently squeegee most of the water from the print's surface before beginning evaluation.

Even with these viewing precautions, it is often necessary to dry a print, mount it, and hang it on the wall for a few weeks before you can make the final critical evaluation.

Washing and Drying Silver Prints

Silver prints should be archivally processed, which simply means removing all residual fixer from the print before drying it. RC paper consists of a photographic emulsion coated on a plastic base. Unlike fiber-based paper, RC paper absorbs few chemicals and can be archivally washed in 5–10 minutes of gently flowing water. Once excess water is squeegeed from its surface, RC paper also dries within minutes.

For fiber-based papers like the Ilford paper recommended in this chapter, it generally takes at least 1 hour of washing in an archival washer to completely remove all chemicals. Archival washers have an individual slot for each print and maintain a gentle water flow across the print surface throughout the washing process. After washing, excess water can be gently squeegeed from both sides of the print. Then they are air-dried by placing them face down on a plastic screen overnight.

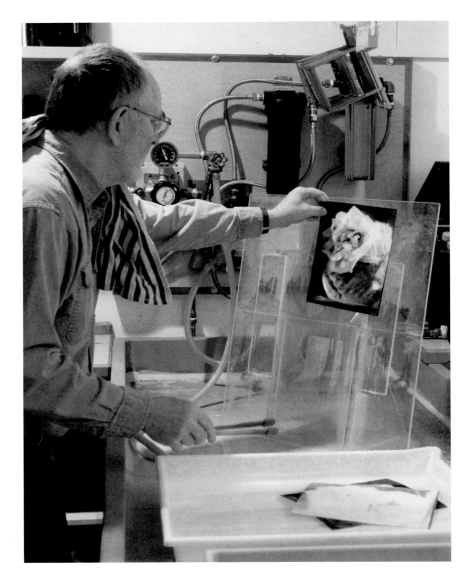

Figure 4-13 View stand.

a basic workflow for silver printing

Things to Know about Processing Silver/Gelatin Prints

It is prudent to use print tongs or wear rubber gloves to protect your hands from the chemicals. We know several old-time silver printers who delight in getting into the developer practically up to their elbows to vigorously agitate the print. These chemicals are mild enough that you can often get away with that practice for years, maybe for a lifetime. But we also know others who eventually developed sensitivity to the chemicals, resulting in nasty rashes. If you do get your hands in the chemicals, do not panic. Rinse the chemical off, dry your hands, and get on with life. But avoiding unnecessary contact seems prudent.

You only need two sets of print tongs: one for the developer and one to be used in both the stop and fix baths. Developer is alkaline and its action is stopped by the dilute acid of the stop bath. Never poke the developer tongs into the stop bath and then return them to the developer or your developer will soon die. If you do absent-mindedly dip the developer tongs into stop bath, rinse them in hot water, and wipe them off before returning to the developer. The stop and fix baths are both mildly acidic and it does the stop bath no harm to get some fixer into it. So one pair of tongs can be used for both baths.

Keep several towels handy in the darkroom. Any small chemical drips can be wiped up immediately, before they dry and form dust in the darkroom. And if you get your hands wet handling a print, you can quickly dry them before touching the enlarger or fresh printing paper.

Both the developer and the stop bath should be made up fresh for each printing session. Fixer, however, can be poured back into a bottle and used for more than one session. To get some idea of how many prints can be processed in a given amount of fixer, read the bottle or package the fixer came in. For the utmost archivalness, fine-art printers often have two fixing baths and the print spends about 5 minutes in each bath. When the first fixer bath nears exhaustion, it is thrown out, replaced by the

second bath, and a fresh second bath is made up. In the end, processing chemicals are a relatively small part of the overall cost of making silver prints. If you want your prints to be archival, it makes sense to err on the side of caution in not exhausting your chemicals.

Variations

The recipe in this chapter is designed to work well for a specific set of materials (printer model, photo paper, negative film, chemistry, etc.). In this section, we would like to present options for working with some variations if you are unable to exactly mimic our recipe. If you cannot work with the same materials as discussed in this recipe, definitely go ahead and try out the process with what you have; the results may not be extraordinary, but they should be sufficiently good to get a feel for working with digital negatives.

- Printer models. Sadly, it seems that the printer model has a very significant impact on the final results. All of the different models seem to lay down ink very differently, resulting in negatives with highly variable density. The steps in this chapter are designed for working with the Epson 2100/2200 printer because it is commonly used by many photographers, and we recommend it for printing digital negatives. You can find steps and curves available for additional printer models on the Web site (www.digital-negatives.com); in particular, we have support for the Epson R2400 printer, the Epson 4000 printer, plus other printer models. See if support for your printer is available. If your printer is not supported, you should still try out the processes in your darkroom; just remember that your results may be merely adequate. Further details on how to set up your printer driver are available in Chapter 9, About Printers.

- Photo paper. Photo paper is fairly easy to substitute. We have used Ilford Ilfobrom paper for our recipe because it is an inexpensive, high-quality paper that is readily available. If you want to use a different paper, we suggest that you use any grade 2 paper or a multigrade paper with a filter set for grade 2. Remember that any paper's grade 2 can easily be different than the Ilford grade 2, so your resulting print may be slightly softer or harder than expected. You should be able to get good results with almost any silver paper working around the same grade.

- Negative film. We recommend that you print using Pictorico High-Gloss White Film. This is an excellent film for producing silver negatives for contact printing. There are a number of other white film materials available that are likely to work well. In particular, you might try Ilford Smooth High-Gloss Media or Oriental Graphica Glossy White Film. Film materials do not use a paper base and will show no texture in the negative. It is likely that these materials will give similar results to using the Pictorico High-Gloss White Film.

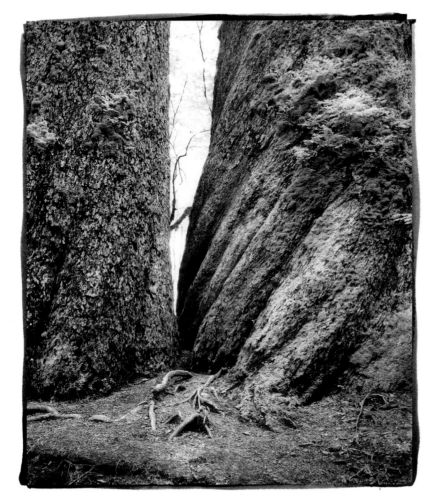

Grove of the Patriarchs 2000 Judith Roan

'Huge trees like these used to cover the Pacific Northwest. Only a few isolated scraps of those forests now remain.'

Palladium

Photographed with a Mamiya 7 medium format camera using black and white film and scanned with an Imacon 646. A mild correction curve was applied to the positive image file which was then inverted and printed as a negative on Pictorico OHP with an Epson 4000 printer using the Quadtone RIP driver. Most of the image correction was applied as a custom quadtone profile in the driver. The digital negative was used to expose a sheet of Arches Platine coated with a lithium/palladium emulsion.

Final print size, about 15 × 18 inches.

5 making a palladium print from a digital negative

In this chapter we provide a recipe for making a palladium print from a digital negative. The process can be rapid. Starting with a good digital image file, a negative can be printed out, a piece of paper sensitized, and the print exposed, developed, and cleared in under half an hour. The procedure given here is one that we use to make many of our own prints. If you follow it closely we can practically guarantee you will make a pleasing print on your first try.

The most problematic part of this recipe is the ready-made correction curve we provide. It was designed for the specific combination of printer, inkset, paper, emulsion, exposure time, and other conditions used in this chapter. However, even if you cannot duplicate these conditions exactly, do not be daunted by the correction curve. Use the one we provide and go ahead and make a print. We think you will be pleased to find how easy the overall process really is. Perhaps you will then be stimulated to read Chapter 7 and learn how to make correction curves that are precisely tailored to your own printing conditions.

Making a pleasing palladium print from a digital negative is relatively easy — just follow the recipe. Making a truly fine, expressive palladium print can be another matter. It requires some artistic sensibility and control over a number of variables that influence print quality. In Chapter 11 we discuss factors that influence digital

negative quality and how these factors might be controlled. This is an area where we continue to experiment and learn.

A convenient source for most of the items used in palladium printing is Bostick & Sullivan (www.bostick-sullivan.com) in Santa Fe, New Mexico. They can supply a kit with the exact paper and chemicals mentioned in this chapter and they also carry larger items such as UV light sources and printing frames.

Box 5.1 Materials Needed to Make a 5 × 7-inch Palladium Print

For preparing the positive image

- A computer with a calibrated monitor (see Chapter 8)
- Photoshop 7.0, CS, or CS2
- An image that has been adjusted to look good on your computer screen
- A correction curve for the platinum/palladium process; the correction curve for platinum/palladium prints and the Epson 2200 is available on the Web site (www.digital-negatives.com) in the section for correction curves as 2200-UCpk-OHP-Pd.acv

For printing the negative

- An inkjet printer; for demonstration purposes we use the Epson 2200
- Pictorico OHP transparency material, letter size (8½ × 11 inches)

For coating the paper

- Platinotype white paper (purchase in 11½ × 14½-inch sheets; each sheet can yield four 5 × 7-inch prints with narrow borders or two prints with generous white borders
- Lithium chloropalladite (10% palladium chloride, 7% lithium chloride in water; purchase as lithium palladium solution #3 from Bostick & Sullivan)
- Ferric oxalate (27% solution; purchase as ferric oxalate solution #1 for platinum/palladium from Bostick & Sullivan)

- Tween 20 (1% solution; purchase as 10% solution from Bostick & Sullivan and dilute to 1%)
- Spreading rod, 5 inches long
- Hair dryer
- Sheet of window glass to support the paper while spreading

For exposing the print

- The digital negative needs to be held tight against the coated paper during exposure or soft, out-of-focus spots will result. You can purchase a contact printing frame with a spring-loaded back that will hold negative and paper tightly. We also find that two sheets of window glass, hinged along one side with cloth tape, works well for print sizes up to 8 × 10 inches.
- Ultraviolet light exposure source

For developing and processing the exposed print

- Four photo trays, 11 × 14-inch capacity
- Potassium oxalate developer, 1 liter (250 grams/liter of water)
- Sodium EDTA and sodium sulfite for the clearing baths, 4 liters total, 2 liters for the first clearing bath and 2 liters for the second bath (1 heaping tablespoon each of EDTA and sulfite per liter of water)

Preparing the Image

You will follow the same basic steps for every image that you want to print as a digital negative. Once you have done this a few times, it will be quick and easy to run through the steps with your own images.

1. Edit. Open a positive, grayscale image file in Photoshop and adjust until it looks on the computer screen as you want it. Interesting images can be printed from

files that are only in 8-bit depth, but the smoothest tones are obtained by working in 16-bit depth at this stage.

2. Duplicate the image. The steps for preparing the image are destructive and are best performed on a flattened image. You should duplicate the image so as not to apply these changes to your original edited file. Go to Image > Duplicate… to open the Image Duplicate window, and change the name to 'My Image Negative.' Click the Duplicate Merged Layers Only check box to flatten the duplicate image (Figure 5-1).

3. Resize the image. Go to Image > Image Size. In the Image Size window (Figure 5-2), change the size to the print size you want for this image (for early experiments, we suggest that you print an image that is approximately 5 × 7 inches) and set the printer the resolution to 360 ppi for Epson printers; for most other printers the resolution should be set to 300 ppi. (More on configuring various printers in Chapter 9, About Printers.)

4. Flip the image. Reverse the orientation of the image (Image > Rotate Canvas > Flip Canvas Horizontal) to make the orientation of the image come out correct in the final print since, when you make the print, the ink side of the negative will be placed against the sensitized side of the paper.

5. Apply the correction curve. If you intend to print the negative on an Epson 2200 using the settings described later, use correction curve 2200-UCpk-OHP-Pd.acv available from the Web site (www.digital-negatives.com). With the image open on the screen, open the Curves window (Image > Adjust > Curves). Along the right side of the window, click Load. Another window will open that allows you to find where you have the correction curve file stored (Figure 5-3). Once you have located the correction curve, click on its icon. The window will change again; click the highlighted Load button at the bottom of the box, and immediately the selected correction curve will appear in the Curves window. The image

Duplicate Image

Duplicate: Palladium figure.jpg

As: Palladium figure copy

☑ Duplicate Merged Layers Only

OK

Cancel

Figure 5-1 Duplicate Image window.

Image Size

Pixel Dimensions: 29.2M (was 3.34M)

Width: 2880 pixels

Height: 3548 pixels

OK

Cancel

Auto...

Document Size:

Width: 5 inches

Height: 6.856 inches

Resolution: 360 pixels/inch

☑ Scale Styles

☑ Constrain Proportions

☑ Resample Image: Bicubic Sharper

Figure 5-2 Resize image.

will become much lighter and washed out. Click OK in the Curves window to finish applying the selected correction curve (Figure 5-4).

6. Invert. Invert the image file from positive to negative (Image > Adjust > Invert). The image will now look like a negative and is ready to print.

Figure 5-3 Load curve.

Printing a Negative on the Epson 2200

The steps in this section provide the precise instructions for printing a digital negative onto Pictorico OHP Transparency Film using the Epson 2200 printer running Apple Macintosh® OSX 10.4. For printing instructions running Microsoft Windows® XP, go to the section 'Printing the Negative on the Epson 2200' in Chapter 4. The instructions for printing are identical both for the White Film and for the OHP Transparency Film, so we provide Windows instructions in Chapter 4 and Mac instructions in Chapter 5.

Figure 5-4 Apply the curve.

Printing the negative requires that the printer be configured in precisely the same manner that an identical printer was configured when the original correction curve was created. This is very similar to printing using color management profiles; so it will seem familiar to anyone who prints with profiles (essentially, a correction curve is a printer profile for the black-and-white printing process that you are using). If you are not familiar with printing with profiles, then you will need to pay careful attention to the various places where the printer driver must be configured. These include configuring

the preview window in Photoshop, and the Printer Properties window for your specific printer model. This is made more complex because each printer driver has a different set of Printer Properties windows.

We have provided a section in Chapter 9 that provides step-by-step instructions for configuring the Epson 2200 printer for both Macintosh OSX and Windows XP. We have also provided specific steps for the Epson R2400 and 4000; additional printers are covered on the Web site (www.digital-negatives.com). If you have one of these supported printers, great; go ahead and follow the instructions for your printer. If you do not have one of these printers, we suggest that you use your printer, but be aware that the results might not be excellent. We have provided some tips for using the Epson 2200 correction curve with other printers in Chapter 9.

1. Adjust the printer in-feed to accommodate media 8½ inches wide and slide in a sheet of 8½ × 11-inch Pictorico OHP Transparency Film, printable side up (there should be a notch in the upper right corner when the printable side is facing you). Make sure that your printer has the Photo Black ink cartridge installed (rather than the Matte Black). This was the ink we used when creating the correction curve.

2. In Photoshop, with the negative image open, open the Page Setup window (File > Page Setup). Select the printer (Epson Stylus Photo 2200) in the Format for list. Select the letter (8½ × 11 inch) paper size and the correct paper orientation (vertical or horizontal). Click OK to close the Page Setup window (Figure 5-5).

3. Now go to File > Print with Preview. On the left you will see the negative image positioned on an 8½ × 11-inch page. This is a reality check. If image size or orientation is not correct, go back to the Image Size or Page Setup windows and correct them. In the lower left of the Print window (Figure 5-6), under the image preview, is a drop box; choose Color Management. In the Options group box, set Color Handling to No Color Management. (We discuss the reasons for these settings in Chapter 9.) Click Print.

4. Turn off Printer Color Management in two places: (1) in the Print with Preview window and later in the Print window.

5. Select the correct print media in the Print window. It is important to use the same media setting that was originally used when deriving the correction curve.

6. Choose Quality rather than High Speed printing and select the highest dpi printing mode the printer will support.

A newly printed negative will have a slightly milky appearance that fades in a few minutes as the inks dry. We often hurry the process with 60 seconds or so under a warm hair dryer. The surface of the negative is delicate. Protect it from fingerprints and abrasion.

Coating the Paper

Platinotype white paper is easy to coat, has great wet strength, and can produce a rich-looking print with velvety blacks. It can be purchased in 11½ × 14½-inch sheets. Tear these sheets in half using a heavy metal ruler to produce sheets that are about 7 × 11 inches in size. This is a good size on which to place the final 5 × 7-inch image.

Mix the following ingredients in a shot glass or other small glass container (Figure 5-9):

- 10% lithium chloropalladite, 10 drops (Bostick & Sullivan's Lithium Palladium Solution #3, originally developed for making Ziatypes, but we like the tone it brings to straight palladium prints)

- 27% ferric oxalate, 10 drops (Ferric Oxalate Sol. #1, no potassium chlorate added)

- 1% Tween 20, 1 drop (helps spreading on some papers, may influence DMax)

Lay a sheet of window glass (about 11 × 14 inches) on a level surface. On a sheet of Platinotype white paper, use a pencil to lightly mark the corners of the 5 × 7-inch image area. Lay the paper on the glass, place the spreading rod along one 5-inch side of the image area, and pour the sensitized palladium mixture on the paper in front of the spreading rod (Figure 5-10). Use the rod to evenly spread the liquid over the entire image area (Figure 5-11). Even spreading will require from 4–6 passes of the rod. In an ideal spreading nearly all of the liquid will be absorbed by the paper, leaving little if any to be blotted with a piece of paper towel after the final pass of the spreading rod. If the humidity is low, you may run out of liquid before a smooth spread is achieved, leaving an uneven coat with no more liquid to repair it. If that happens, you will have to spread another piece of paper. But this time, extend the volume of the liquid with

Figure 5-9 Counting drops to mix emulsion.

several drops of water until you have enough for an even spread. On the other hand, if considerable liquid is still left after a smooth spread has been obtained, reduce the number of drops of palladium and ferric oxalate solutions (but always keep the number of drops of palladium solution equal to the number of drops of ferric oxalate).

A good coating looks dark rusty orange after drying and has the capacity to yield a dark velvety black with sufficient exposure. Undercoating looks light orange and cannot develop a good black. Excessive overcoating, such as puddles, may dry with a sensitized upper layer that does not adhere to the paper, but washes off during development. Thus, overcoating will also result in failure to develop good blacks. Fortunately, there is a relatively broad range of conditions between these two extremes that gives deep blacks and a good print.

Figure 5-10 Pouring emulsion.

After spreading, it is good practice to let the wet paper 'rest' for several minutes before drying with a hair dryer. During the rest period, liquid on the paper has a chance to diffuse and even-out small irregularities in the spread. In our experience, coating with a rod produces such an even coat that the rest period is not very critical. However, rod coating becomes impractical for print sizes much above 8 × 10 inches. Larger prints must be coated by brush and some skill is required to produce a brush coat that looks good on a large even-toned expanse such as an area of clear sky. In such cases using slightly more liquid than normal and allowing an adequate rest period both help in getting a good even coating.

After the rest period, use a hair dryer set to moderate heat to dry the paper (Figure 5-12). Dry both sides of the paper until the buckles have evened out and the emulsion is completely dry to the touch. For some platinum/palladium printing

Figure 5-11 Spreading emulsion.

methods, such as Sullivan's Ziatypes, image formation is critically dependent upon maintaining a controlled level of water moisture in the coated emulsion. In contrast, the palladium printing method we describe here is relatively insensitive to the moisture content of the emulsion. Reproducible prints, with warm tonality and deep blacks, can be made with emulsions exposed immediately after hair dryer treatment.

Exposing the Print

A platinum/palladium emulsion is sensitive to ultraviolet light wavelengths including UVB (290–320 nm) and UVA (320–380 nm). UVB is strongly absorbed by ordinary plate glass, so in practice we are only interested in UVA. There are many possible sources

Figure 5-12 Drying bottom.

of UVA light, ranging from the sun to industrial plate burners with metal hydride lamps and integrating timers. Sandy King has written a good review of currently available UV light sources with a discussion of their relative merits for platinum/palladium printing (www.unblinkingeye.com/articles/light/light.html).

The sun is clearly the most available and inexpensive UV light source. However, if you live in the Northwest as we do, the availability and intensity of sunlight are too frustratingly irregular to make it a practical exposure source. In terms of all-around practicality, perhaps the best compromise is a bank of UV-emitting fluorescent tubes. If you can build a simple plywood box and do some elementary wiring you can build your own exposure unit following plans such as those given in Sullivan and Weese's book (The New Platinum Print, Sullivan and Weese, 1998, Working Pictures Press). A nearly identical unit can be purchased ready-made from Bostick and Sullivan. Since much of the cost of the unit is in the bulbs themselves, it makes some sense to buy the ready-made unit unless you really want a do-it-yourself project. Fluorescent bulb exposure units do not emit as much UV light as some other units, and exposure times for denser conventional negatives can easily range as high as 20 minutes or more. With digital negatives, however, density ranges are under much more control and exposure times generally are no more than 4–6 minutes. For this demonstration we will assume you have access to a fluorescent exposure unit similar to the one sold by Bostick & Sullivan. (More details on various exposure options in Chapter 6, Exposure.)

During exposure the negative must be held tightly against the coated paper. For larger prints (11 × 14 inches and up) the only practical way to ensure tight contact is to use a vacuum easel. For smaller prints, however, there are a couple of adequate low-tech solutions. One solution is to use a printing frame in which the negative and the sensitized paper are sandwiched between a sheet of glass and a plywood back. The whole sandwich is held together in a wooden frame and spring pressure against the plywood forces the negative and paper tightly together. New printing frames in various sizes can be purchased from suppliers such as Bostick & Sullivan.

An even simpler solution is to use two sheets of window glass, edges sanded to remove the sharp edges, and loosely hinged along one side with cloth tape (Figure 5-13). Open the package and on top of the lower glass lay a thin sheet of some compressible foam. Place the sensitized paper and negative on top of the foam and lower the upper sheet of glass. The weight of the upper glass will be sufficient to keep a small negative and print in tight juxtaposition to each other.

It takes a few minutes for UV fluorescent tubes to warm up to maximum output. Therefore, to ensure reproducible exposures, we generally turn the unit on, let it warm up at least 5 minutes before the first exposure, and leave it on for the entire printing session.

After the unit is warmed up, slide the glass-paper-negative sandwich under the tubes, time an exposure of 5 minutes, and slide the package back out again. You may want to do some tests on your own unit, but in our experience 5 minutes under a fluorescent tube unit is about right to achieve maximum black when printing through clear Pictorico OHP substrate.

Developing the Exposed Print

Place the exposed print face-up in an empty tray and have about a liter of potassium oxalate developer ready in a wide-mouthed container. This is the magic moment. Flood the surface of the print in one smooth pour (Figure 5-15). In an instant the image will transform to a nearly fully developed print. Keep sloshing the developer over the print for another minute or so to allow maximum black to emerge, and then pour the developer back into the wide-mouthed container. Potassium oxalate developer is essentially immortal. After many prints some volume will be lost, so mix up a bit more to top it up. The developer turns a deep green as it is used, and some black sludge will settle to the bottom of the storage bottle. If it offends you, decant off the clear top liquid and throw away the sludge.

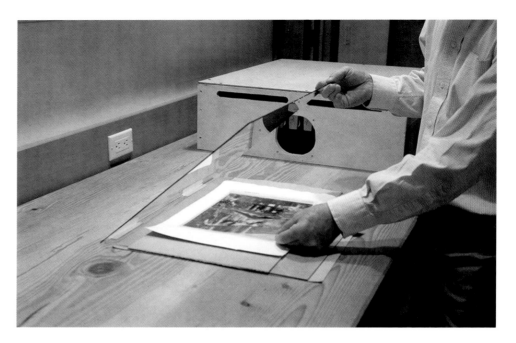

Figure 5-13 Placing the negative over the paper.

After pouring off the developer, begin the clearing process by rinsing the print, still in the developing tray, with several changes of water (Figure 5-16). The point here is to quickly remove all loosely bound chemicals. You will see black streaming away from the darkest areas of the print and the highlights will change from dark orange to light yellow. After several water rinses, the print is transferred to the first clearing bath, a solution of sodium sulfite and sodium EDTA. After 5–10 minutes in this first bath the print highlights should look completely white. To make certain that all residual ferric oxalate sensitizer has been removed, the print is then drained and transferred to a second sulfite-EDTA clearing bath for another 5–10-minute soak. Finally, the print is placed in an archival print washer, washed for about an hour and air dried on a drying screen. At the end of a printing session it is our practice to throw out the first clearing

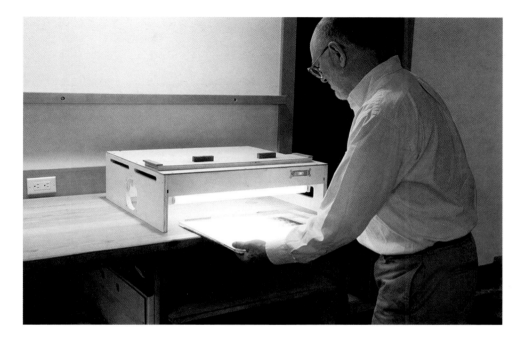

Figure 5-14 Loading the UV unit.

bath (it usually has acquired a slight greenish tinge) and save the second bath. At the next printing session the second bath now becomes the first bath and a fresh second bath is prepared.

Variations and Fine-Tuning

Dry the print and evaluate it under light similar to that where it eventually will be hung for display. Chances are, it will be pleasing but not exactly what you intended. What to do next?

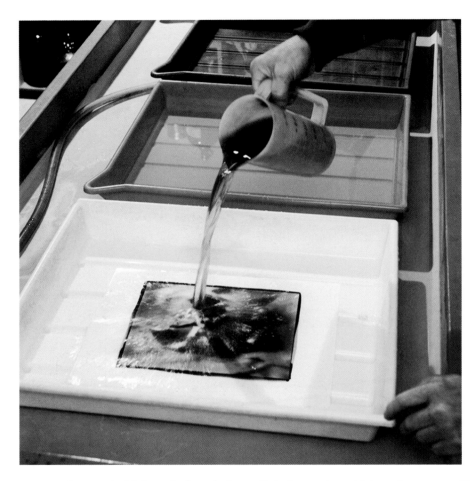

Figure 5-15 Pouring the developer.

In the good old days, before desktop digital negatives, if the print was at all close to its intended appearance, there was strong motivation to find some way to tweak or fine-tune the print without going back and laboriously making a new negative. Those tweaking methods are still available. For example, if the print is too dark or too light

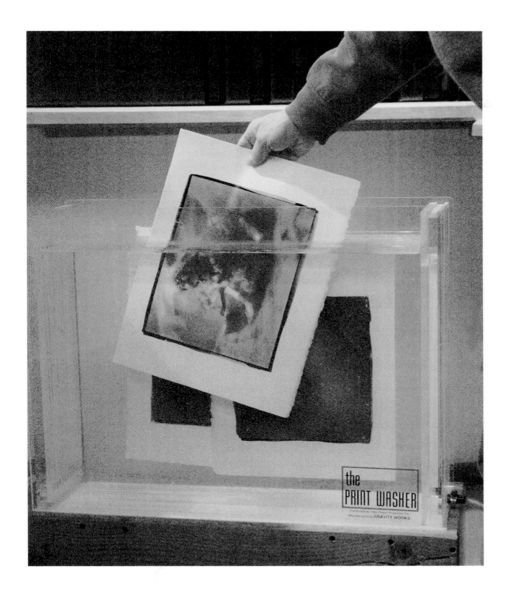

Figure 5-16 Washing the print.

overall, it is legitimate to try increasing or decreasing the exposure. However, if the black and white end points of the digital negative were set properly, you will find that decreasing the exposure quickly leads to a weak-looking print with no true black in it. Likewise, increasing the exposure too much will lead to loss of clean whites in the highlights. Generally, we find that if you have to decrease exposure by more than 25% or increase it by more than 50%, you are better served by going back to the original image file, lightening or darkening the image at that point, and printing a new negative.

For contrast control you have more options. If the image is too flat, it is possible to increase the contrast of the palladium emulsion rather than making a new, more contrasty negative. The best agent for contrast control of a palladium (or platinum) image is a salt of platinum called disodium chloroplatinate (rediscovered by Richard Sullivan and often abbreviated as Na_2). All contrast agents we know of cause an increase in graininess of the final print, but Na_2 induces much less grain than other agents. In addition, in normal amounts Na_2 causes no reduction in printing speed of a palladium emulsion. In addition to increasing contrast and inducing mild graininess, Na_2 cools the image tone toward a more neutral black. Bostick & Sullivan sell Na_2 as a 20% solution. Since small amounts of Na_2 have large effects on image contrast, we usually take some of the 20% solution and dilute it to 5% (a four-fold dilution) and dilute some more to 1.25% (a sixteen-fold dilution). One drop of 1.25% Na_2 added to 10 drops of palladium causes a detectable increase in image contrast. One drop of undiluted 20% solution per 10 drops of palladium causes a large increase in contrast.

If your image is too contrasty, you are out of options. Go back and decrease the contrast of the starting image and make another negative. A pure palladium emulsion is just about the softest photosensitive emulsion known to photography and there is no way to make it softer.

The good news with digital negatives is that it is no longer such a big deal to go back, tweak the original image, and simply make a new negative. When we are trying

for the best possible print we usually go that route, rather than playing with exposure or emulsion contrast.

You will notice that for UV-based processes (such as palladium printing in this chapter) we recommend printing the negative on Pictorico OHP transparency material. In contrast, for visible light processes, such as printing on silver/gelatin paper (Chapter 4), we recommend printing the negative on a different substrate, Pictorico High-Gloss White Film. Ideally, we would like to print all negatives on glossy white film because Epson Ultrachrome inks print very smoothly on this substrate with little beading up of individual dots and less apparent graininess. Unfortunately, although you can blast enough white light through glossy film to expose silver paper, the optical brighteners incorporated into glossy film make it nearly opaque to UV light. So, for UV processes we use UV-transparent Pictorico OHP. The good news is that the increased graininess of OHP negatives tends to disappear in the matte surface of a typical paper used for platinum/palladium printing.

The recipe given in this chapter specifies a pure palladium emulsion because (1) it is a very simple emulsion, (2) pure palladium is a very soft emulsion and yields a very long range of smooth tones, and (3) we like the warm tone of palladium prints (especially when spiked with lithium). However, if you check any standard text on platinum/palladium printing you will find there are numerous alternate metal combinations that can be used, and many of them yield prints of quite diverse color and feel. The only slight drawback to experimenting with all these lovely metals is the fact that the canned correction curve we give you for a pure palladium emulsion will almost certainly not work very well for other metal combinations; thus, you will have to learn to make your own custom correction curves, as we describe in Chapter 7. But learning to make your own curves was the very next thing on your to-do list anyway, was it not?

'I have always been attracted to examples of life growing under extreme conditions. The life of the lichens contrasts strongly with the rock.'

Platinum/Palladium

The original image was captured using a 4 × 5 view camera onto TMax 100 film. The original scene had very little contrast; maybe one stop between the highlights and the shadows; so I shot a very long exposure at dusk to add contrast onto the film; about 20–30 minutes (I lost track of time during the exposure). The image was scanning and edited in Photoshop to further increase the contrast and make the overall contrast more uniform. A negative was printed onto Pictorico OHP film and contact printing onto a Platinum/Palladium emulsion on Arches Platine paper. The emulsion had about 20% Palladium to add just a touch of warmth.

Final print size, about 8 × 10 inches.

Lichens & Rock 1999 Brad Hinkel

6 exposure

A key element to making excellent prints from digital negatives is setting a precise exposure. As with most of the elements of digital negatives, the key to good exposure is consistency. Consistency requires a reliable light source, a reliable quantity of light, and a precise duration of exposure. We will also define a specific strategy for determining the proper exposure for any process.

This chapter covers some options for light sources, provides the steps for determining the proper exposure for your process, and discusses some steps for measuring and maintaining a consistent light source.

Light Sources

The two main categories of light sources for photographic printing are visible light and ultraviolet (UV) light. Silver/gelatin emulsions are sensitive to visible light and for that reason must be handled in a darkroom that can be made completely dark. Fortunately, silver/gelatin emulsions are most sensitive to light at the blue/green end of the spectrum and are fairly insensitive to red/orange light. Therefore, it is permissible to work under a dim red/orange safelight for limited periods of time. Be aware, however, that silver/gelatin paper can be fogged even by a safelight if left exposed for extended

periods. There is a wide variety of possible sources for visible light, ranging from bare tungsten bulbs to sophisticated variable contrast enlargers.

Most other photographic processes, including platinum/palladium printing, use emulsions that are only sensitive to UV light. Sensitivity is highest to wavelengths between 320 and 380 nanometers (relatively safe UVA) and there is essentially no sensitivity to longer wavelength light such as that emitted by a normal tungsten bulb. Papers can be coated and processed in a room with a normal level of tungsten illumination, but banish residential fluorescent lights from the workspace since these lights emit enough UV to cause trouble. There are several good options for UV light sources, but we will focus on three of the most popular: the sun, a bank of special UV-emitting fluorescent tubes, and graphic arts plate burners.

Visible Light Sources

The most common light sources for exposing silver/gelatin papers and other visible light-sensitive materials are tungsten light bulbs, enlargers, or UV fluorescent bank lights. It is not absolutely necessary to purchase an enlarger for exposing silver/gelatin prints from digital negatives as these will be contact printed, not enlarged.

Normal Tungsten Light Bulbs

Digital negatives are the same size as the final print and are made to be contact printed, not enlarged. Therefore, if you use a graded paper with a fixed contrast built into the emulsion, the print can be exposed with a light source as simple as a bare tungsten bulb. A bare bulb emits a lot of light, which can be useful when exposing a print through the rather dense Hi-Gloss White Film recommended for printing digital negatives for silver/gelatin prints. We recommend a 100 watt bulb in a simple, round reflector with

a long plug-in cord (Figure 6-1). The cord can be used to hang the bulb from the ceiling. In order to obtain even lighting over the entire print, hang the bulb at a height that is higher than the longest dimension of your print. (For an 11 × 14-inch print, hang the bulb at least 14 inches above the print.) If you have a darkroom timer, plug the bulb into it. Alternatively, raise the bulb higher or use a lower wattage to lengthen exposure time to a range that can be easily timed manually.

Photographic Enlargers

Instead of fixed-contrast graded papers, you may wish to use variable-contrast silver/gelatin papers because of the additional image control they afford. Variable contrast papers actually contain two different emulsions: a low-contrast emulsion sensitive to green light and a high-contrast emulsion sensitive to blue light. To control the contrast of these papers, you need a light source, such as an enlarger, whose color can be varied from green to blue. Enlargers made for printing color have the ability to produce light by using a full range of colors (Figure 6-2). Using these enlargers for variable-contrast black-and-white printing, just vary the magenta and yellow controls to vary the amount of green and blue. Some enlargers are dedicated to variable-contrast black-and-white printing and provide direct control over the green and blue light. You could also use an enlarger with no color capability by purchasing a set of contrast control filters to slide into the optical path (usually just below the lens). There are many good, used enlargers becoming available as workers abandon their wet darkrooms in favor of digital photography. If you buy a used enlarger, try to get color capability (either full color or just variable contrast) because that is more convenient than using filters. And make sure that it comes with a negative carrier, and that it has a lens. The negative carrier and lens are needed for the enlarger to function without extensive light leaks. Try to get a lens with as large an aperture as possible — f5.6 will work, but f4 or even f2.8 is better. In setting up the enlarger, put in the empty negative carrier and raise the head so that the focused light beam just covers the area of your print. Then throw the light

Figure 6-1 Light bulb.

out of focus a bit so that any dust or other defect in the optical path is not focused on your print. When using variable-contrast paper, use the lowest contrast setting that will still produce a rich black when properly exposed. A contrast grade of about 1 usually works well.

A UV exposure unit with a bank of UV fluorescent tube emits light not only in the UV range, but also visible light. So, if you obtain a UV fluorescent exposure device to use for alternative processes, you can also use it to expose graded silver/gelatin papers.

Figure 6-2 Enlarger.

UV Light Sources

We recommend three light sources for exposing alternative process materials that require ultraviolet light: the sun, fluorescent bank lights, or a platemaker. These generally provide a trade-off between price and precision.

The Sun

The sun is a good, cheap source of UV light, and it is great to be able to work outdoors when printing. In fact, for over one-third of photography's history it was the only source of light. The sun is an extremely consistent source of UV light in outer space; it is still a pretty reliable source in places such as Santa Fe. Unfortunately, here in Seattle the intervening clouds and atmosphere make it less reliable. If you live in a clime where using the sun is feasible, you will still probably need to redetermine your base exposure each time you have a printing session. You could take visible light readings off a standard gray card and try relating those readings to the sun/UV exposure you determine via test strips. But such visible light readings will only provide a rough estimate of correct UV exposure under different circumstances since the ratio of UV-to-visible light in sunlight can be quite variable. Even with all these caveats, however, the sun is still a great light source if you just want to try making a few prints without investing in an expensive UV source.

'Often the most fleeting subjects provide the most vivid details. This tulip opened fully to capture the full light of day.'

Platinum

Captured using a 4 × 5 view camera onto TMax 100 film. The image was scanned into Photoshop and edited to brighten the flower and ensure that the background was completely black. A negative was printed onto Pictorico OHP film and contact printing onto a Platinum emulsion on Arches Platine paper. The emulsion had 100% platinum to create a neutral almost cool final print.

Final print size, about 8 × 10 inches.

Tulip 2000 Brad Hinkel

Figure 6-3 UV exposure unit.

Fluorescent Bank Lights

A UV exposure unit (Figure 6-3) using a bank of UV fluorescent bulbs in a wooden box is probably the most popular light source for alternative processes printing since you can make this type of unit yourself or buy a quality, premade unit. But expect to pay $250 for parts and twice as much to purchase one built for you. (See the Appendix of Resources for Alternative Processes for online instruction and sources for these units.) The contact printing frame containing your paper is inserted under the UV lights to expose the paper. The UV lights remain at a consistent 4 to 5 inches above the photographic paper, so the only variable for exposure is time.

Platemakers

A platemaker is a professional UV exposure unit once used to make printing plates (Figure 6-4). This is the Cadillac of UV exposure units. A good platemaker includes a vacuum frame for very sharp contact prints, can make prints up to 20 × 24 inches or larger and includes a light-value integrator for very precise exposures. These units are fairly large and generally require industrial voltages (220 in North America). These units were also once very expensive, but now used units are increasingly available fairly cheaply. Probably the most common units are made by Nuarc. These are often available on eBay and other online resources for less than $1000. But make sure you are able to move it and connect it to your electricity.

Figure 6-4 Platemaker.

Exposure

For printing images from digital negatives, you need to determine one specific exposure for each photographic paper and process that you will be using. For using digital

negatives, we set the proper exposure as the minimum time necessary to print to maximum black (or DMax) using the target negative material. We test for DMax by printing on our target photo paper through the specific negative material (white film or transparency film) to determine the minimum time for which the density of the photo paper is the same with or without the negative material. The minimum time can be easily calculated by printing using a test strip.

Steps for Determining the Base Exposure

1. Prepare a piece of printing paper as you would normally (Figure 6-5). For silver emulsion papers and some other papers, the paper has been prepared for you. For most alternative processes, this involves coating a piece of art paper with chemistry. Typically, a 5 × 7-inch sheet is sufficient.

2. Cut the 5 × 7-inch sheet into three or four strips about 1½ inches wide. Three strips is usually enough to determine the base exposure.

3. Get a piece of the appropriate negative material (white film for visible light processes and transparency film for UV light processes) cut to about 1 × 7 inches. Place the negative material so that it covers half of the test strip along the length of the strip (Figure 6-6).

4. Get a piece of material that is dense enough to completely block the exposure light. A piece of standard 1/16 cardboard or the black plastic packing for photographic materials both work well (Figure 6-7). Cover the printing paper and negative material so that about 1/4 of the length of the test strip is exposed. Place the partially covered test strip under the exposure light and expose the first 1/4 of the strip. For most light sources and printing materials, make the first test exposure

Figure 6-5 A normal paper. Prepare a piece of paper normally.

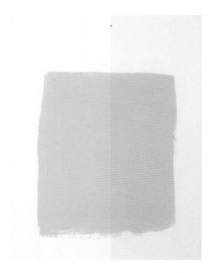

Figure 6-6 Cover with negative material. Lay a piece of plain negative material across the emulsion.

Figure 6-7 Cover with cardboard. Cover most of the image to make the first exposure.

Figure 6-8 Cover and expose again. Make additional exposures along the entire test strip image.

about 30 seconds long. You will find that your test exposures will need to be longer or shorter with some experience.

5. Move the light-blocking material down so that 1/2 of the strip is now exposed. Expose it again, using the same test time as in the previous step (Figure 6-8).

6. Move the light-blocking material down again so that 3/4s of the strips is exposed and expose it again.

7. Finally, remove the light-blocking material and expose the test strip a fourth time.

The test strip now has four small sections that have been exposed to four different durations of light: 30, 60, 90, and 120 seconds (or 1×, 2×, 3×, and 4× test exposure time).

Figure 6-9 Develop normally. Develop the print normally; find the time for maximum black.

Not covered by film Covered by film

Exposure to low

Correct Exposure

Figure 6-10 Examining the test strip. Base exposure text on a piece of sensitized photo paper.

8. Remove the printing paper and develop it normally (Figure 6-9). Complete the entire process of development to ensure that the process will be the same as you will perform when developing your images. Dry the printing paper as well.

9. Take a close look at the printed test strip (Figure 6-10). The lightest value step has been exposed for 1× the exposure time and so on, up to the darkest step. The first step, where the covered and uncovered parts of the test strip are the same dark black, was exposed for the correct base exposure time. If none of the covered parts of the test strip are as dark as the uncovered parts, then the exposure time was too short; make it 4× as long and repeat the process. If the entire test strip is solid black, then the exposure time was too long; make it 4× as short and repeat as well.

10. Once you have the correct base exposure time, take careful notes to ensure that you can repeat it. For many of the light sources used for printing digital negatives, the only variable element of the exposure is the exposure time. But for some, like using an enlarger, you may need to note the aperture of the enlarger lens and the height of the enlarger head. You should also take notes on the process that you have tested; note the target printing paper and development process.

The instructions for printing images onto both silver and palladium in Chapters 4 and 5 assume that the base exposure is determined using this process. You may have a very different light source than we are using, but if you determine the correct base exposure the instructions in these chapters will work well. You will need to determine the base exposure for your darkroom in order to use the instructions provided in these chapters.

You will also need to determine the base exposure as the first step for creating a correction curve for your own specific processes. Chapters 4 and 5 are merely quick starting points for printing with digital negatives, and give you a chance to practice determining the base exposure. But learn to determine your exposure quickly as you will be repeating it every time you change your printing processes.

We have found that setting the base exposure to be the amount of light that just produces DMax through the negative products good results for printing with digital negatives, and it has the added benefit of being fairly easy to reproduce in different labs using different equipment.

A Tool for Consistent Visible Light Exposures

A darkroom light meter, such as the one sold by Ilford (Figure 6-11), is a handy tool for measuring the light output of a visible light source. If you measure both the brightness of a light source and the time for a correct base exposure, you can return at a later

Figure 6-11 Ilford meter.

date, adjust the light source to the same brightness (usually by raising or lowering it), and proceed with some confidence that the previously determined exposure time will be the correct one.

Unfortunately, there is no readily available gadget for measuring UV light (UV light meters tend to be expensive). So, for UV light you will have to go back to the test strip to redetermine base exposure if any conditions change.

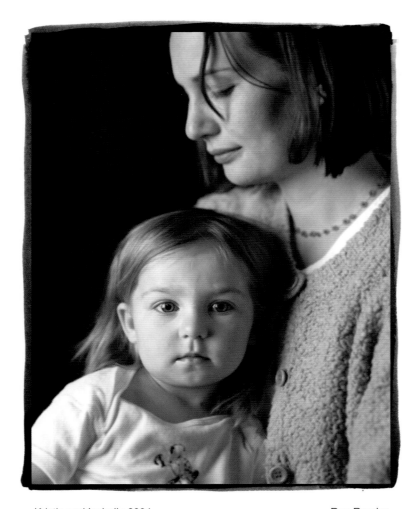

'Isabella distrusted the camera at first and gave me this wide-eyed, wary stare. Later she relaxed and started bossing us around.'

Palladium

Photographed with an 8 × 10 inch Canham view camera using Kodak Tmax 400 film. The film was scanned with an Epson 1680 flat bed scanner, a correction curve was applied to the image file, it was inverted, and a negative was printed on Pictorico OHP using an Epson 4000 printer and the Quadtone RIP driver. The digital negative was used to expose a sheet of Arches Platine paper that had been coated with a pure palladium emulsion.

Final print, about 15 × 18 inches.

Kristin and Isabella 2004 Ron Reeder

7 making correction curves
for digital negatives

The best part about making digital negatives is the ease with which the contrast range of the negative can be precisely tailored to the contrast range of the particular emulsion you wish to print on. The use of digital negatives actually got its start because of the difficulty of producing enlarged wet darkroom negatives for platinum printing. It is not all that hard to produce an enlarged wet darkroom negative, but to produce one of a predetermined density range can be challenging. Digital technology mechanizes the process and makes it easy to control density range.

The key to making good digital negatives is learning how to derive a good correction curve. Basically we think of a correction curve as a type of profile (similar to color printer ICC profiles): it is an adjustment put in the middle of the overall printmaking process to ensure that the image tones you carefully set within the computer will be closely matched by the image tones in the final print.

To make a correction curve, start with an image that has known tones — normally this test image is a grayscale step tablet composed of defined shades of gray — run it through the printing process, and measure how much each tone is distorted by the time it reaches the final print. Knowing how much distortion there is in the overall process, it is a simple matter to derive a correction curve that will correct for those distortions and make the final print closely resemble the starting image.

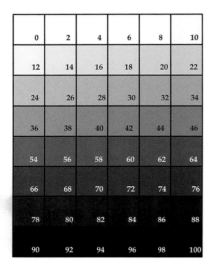

0	2	4	6	8	10
12	14	16	18	20	22
24	26	28	30	32	34
36	38	40	42	44	46
54	56	58	60	62	64
66	68	70	72	74	76
78	80	82	84	86	88
90	92	94	96	98	100

Figure 7-1 Page o' steps.

It is important to realize that every printing process distorts the starting image to a different degree and therefore requires a different correction curve. A good correction curve will be specific to one set of printing conditions — exposure time, emulsion chemistry, paper substrate, developer, and so forth. Hopefully, the correction curves we offer in this book will get you in the ballpark and allow you to make a reasonable print, but you should get comfortable with creating correction curves yourself so that you can use one that is tailored exactly to your own printing conditions.

You should get comfortable creating correction curves so that you can create a new one whenever you make changes to your process.

A Good Step Tablet Print

You need first to create a good step tablet print for the process you want to measure. Follow the steps in Chapter 6 to determine the correct exposure for your specific process. Remember that, when using digital negatives for printing, we set the proper exposure as the minimum time necessary to print to maximum black (or DMax) using the target negative material.

Open the step tablet image in Photoshop®, invert it to make a negative, print the negative onto the appropriate substrate (white film or transparency film), then use this negative to make a positive print of the step tablet for the process of your choice. You can obtain the tablet image on the Web site at www.digital-negatives.com. For this, you will print a negative of the step tablet image and make a print of this image in exactly that same way that you intend to print the final image. Follow the exact same steps for preparing the image outlined in Chapter 4 (for silver prints) or Chapter 5 (for palladium prints and for other processes), except that you will skip the step for applying a correction curve; at this point, you do not have the correction curve to apply.

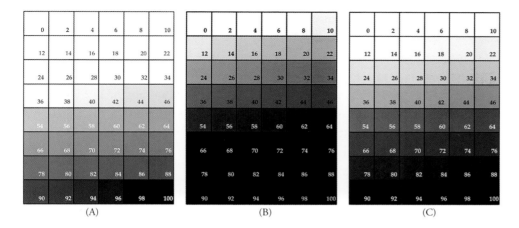

Figure 7-2 Good and bad step tablet prints. (A) Too light. (B) Too dark. (C) Good light and dark values.

Proceed with printing a negative of the step tablet and making a final print using the specific steps for your final process. Remember, every part of the step should be identical, except for applying the correction curve.

A good step tablet print contains a full range of gray values through the middle of the tablet with some white steps (these are paper white) and some black steps (these are maximum black) (Figure 7-2).

If you follow the steps for determining the precise exposure, ideally only the last square in the step tablet (100) will be pure black or DMax. In reality, it is likely that a few squares near to this value will also be pure black. Do not worry about this; the correction curve that you are creating will be calibrated to your specific exposure. If there are no pure black or pure white squares in your step tablet, then your exposure is too long or too short, respectively. Revisit your exposure test; often there is something in your process that you did not repeat in exactly the same manner as you did for your exposure test. A common mistake is not to set the printer settings exactly the same. Check for these mistakes before you redo your exposure test (Figure 7-3).

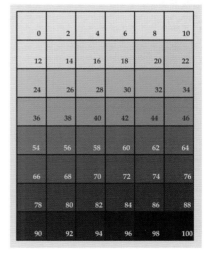

Figure 7-3 A scan of a real test tablet.

Develop and dry the exposure step tablet normally. It is important that you follow all of the development steps carefully, as this step tablet print will be your master calibration print. Also, it is important that the print be dried thoroughly, as any moisture remaining in the paper can lead to small variations in print density. The easiest way to dry the prints is to use a hairdryer on the low or medium setting for 1–2 minutes to dry the print.

Making a Good Scan

Scan the developed step tablet print it into the computer to determine the resultant densities. You will want a scanner that can scan the full density range of your paper; that is, a scanner that can scan the density from paper white to maximum black for your process. Most scanners purchased within the past few years should be able to scan this range well.

1. Place the developed step tablet print onto your scanner, run the scanner software, and create a preview scan for the print.

2. When scanning, you need to make sure that your scanner does not add any correction; this would change the shape of the density curve and mess up the overall process. The software for many scanners will automatically try to correct your scan.

3. Check to make sure any options for auto color, auto levels, or auto curves are turned off.

4. If your scanner has an option to preview the histogram, take advantage of the feature. Often the scanner automatically will set the black and white points for your image in order to maximize the image contrast. If necessary, pull the black and white points for the histogram back out to prevent the scanner from adding any contrast (Figure 7-4).

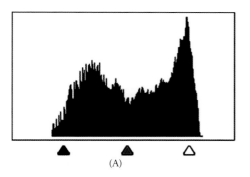
(A)

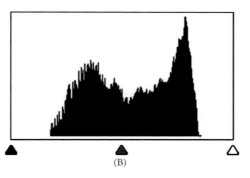
(B)

Figure 7-4 Scanner histogram. (A) The scanner software may try to adjust the histogram. (B) Adjust the histogram so that it scans the image in unaltered xxx.

5. If your scanner has no option for previewing a histogram, it is likely that the scanner will automatically adjust the black and white points for your image. If there is no way to turn off this automatic adjustment, you will likely be unable to create a good correction curve using your scanner. You will need to obtain software that allows for these adjustments.

6. Set the scanner software to make a black-and-white or grayscale scan. Set the scanner software to scan at 16 bits per channel at a moderate resolution, around 100–150 ppi.

7. Scan the image. The resulting scan will likely be somewhat flat with no pure white values and no pure black values.

Adjust the Scanned Image to Full Contrast

1. If you run your scanner software outside of Photoshop, run Photoshop and open the image of the step tablet. If the scanner scans using a different gray working space than you have configured in Photoshop, Photoshop will display the Embedded Profile Mismatch window.

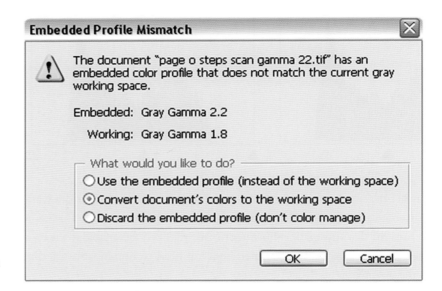

Figure 7-5 Embedded Profile Mismatch window.

Select Convert document's colors to the working space, which should be the default option. (More on working spaces in Chapter 8, Calibrating the System.)

2. Blur the image to eliminate any slight variations in the step tablet print. Go to Filter > Blur > Gaussian Blur (Figure 7-6) and set the radius; typically a radius of 3–4 pixels is sufficient. Use the highest radius that allows you to read the numbers in the step squares. You will need to read these when you record the data for the correction curve.

3. You then need to adjust the contrast of the scanned step tablet image. The original step tablet image had a range from 0% (white, or 255 in Photoshop units) to 100% (black, or 0 in Photoshop units), so adjusting the scanned step tablet image to the same range will allow you to measure the curve for your printing process from the

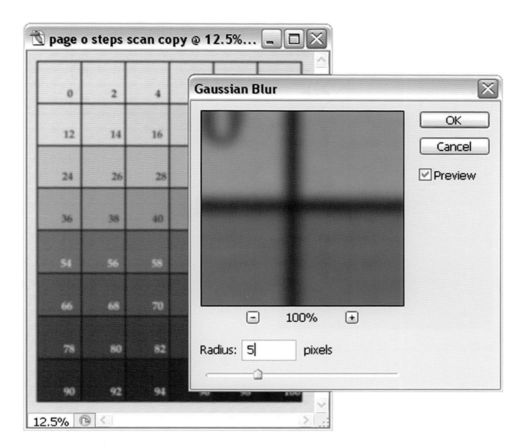

Figure 7-6 Gaussian Blur window.

original step tablet to the printed step tablet. You can make this adjustment using levels; go to Image > Adjustments > Levels. . . . Bring in the black and white point sliders until they are just under the darkest and lightest points of the histogram. This will make image have full contrast from black to white (Figure 7-7).

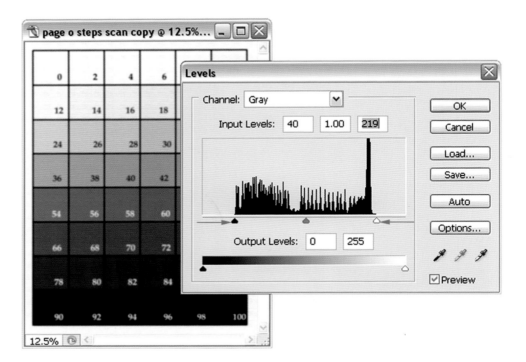

Figure 7-7 Levels window.

Read the Values from the Scanned Image

Now, measure the resulting density for each square in the scanned step tablet.

1. Select the Info palette and make sure that the grayscale values are displayed; they are listed as K values (or percent black). Click the eyedropper symbol to access the menu and select Grayscale (Figure 7-8).

Figure 7-8 Info palette and menu. Select the eyedropper on the Info palette to access the menu; select Grayscale.

Figure 7-9 Reading values.

2. Move the cursor over the step tablet image, and the Info palette will display the K value for the pixels underneath the cursor (in this situation the K value is essentially identical to percent gray value). As shown in Figure 7-10, make a table with two headings, Input and Output. Input is the percent gray value written within each square of the step tablet. Output is the K value you read from the Info palette for that particular square. In Figure 7-9, the eyedropper is located in a square labeled with the Input value of 20% and the Info palette shows an Output K value of 11%.

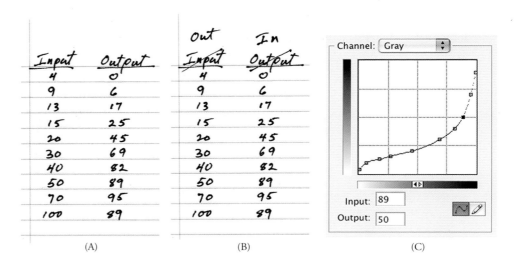

Input	Output
4	0
9	6
13	17
15	25
20	45
30	69
40	82
50	89
70	95
100	89

Out / In

Input	Output
4	0
9	6
13	17
15	25
20	45
30	69
40	82
50	89
70	95
100	89

Channel: Gray

Input: 89
Output: 50

(A) (B) (C)

Figure 7-10 Making a correction curve.
(A) Step 1. (B) Step 2. (C) Step 3.

You do not have to measure every square of the step tablet, but measure more squares at the light and dark extremes since there will be greater changes to the curve in these parts. You will also likely have several input squares that read an Output K value of 0% (often the input squares from 0 through 20 or more will produce an output value of 0%). You need only to use the data for the last square, the one adjacent to the real density values. Similarly, you may have a few squares that read an Output value of 100%; pick the square that is adjacent to the real density values. When you are finished, you should have a table of paired Input/Output data points somewhat like the one shown as step 1 in Figure 7-10.

3. Make a simple table on a sheet of paper that lists these values or, better yet, make the table on the back of the step tablet print that you scanned into the computer. You now have a table that shows the relationship between the original Photoshop values and the final densities on the print (i.e., an original Photoshop value of 40% maps to

a print density of 24%, and so on). The correction curve uses the inverse of this table to correct each value in Photoshop before printing. With the correction curve in place, the Photoshop values will map directly to the target print densities (i.e., an original Photoshop value of 40% now maps to a print density of 40%) (Figure 7-10).

Creating the Correction Curve

The data you collected from the scanned tablet in step 1 (Figure 7-10) describes how the original image was changed during the transition from a Photoshop image into a final print. You want your correction curve to do the exact opposite processing; so merely change Input to Output and Output to Input on your data table as shown in step 2. Now you have the data for your correction curve.

To build the curve, pick 10–15 Input/Output pairs from the table created in the previous section (Figure 7-10). Pick more pairs at the extremes (light and dark) of the curve since there will be greater change in this area of the curve. These are the values that show the highlights and shadows in the final print.

Open the Photoshop Curves window (Figure 7-11); go to Image > Adjustments > Curves. Typically, we apply this adjustment directly over the scan of the step tablet to see the result of the correction curve. Make sure the curve values are being measured in percent (just click a point on the curve to see if the Input and Output values are shown as percents or as values from 0 to 255; if the latter, click the double arrow in the middle of the gradient below the curve to change to percent).

Now you can enter the Input and Output values from your data (Figure 7-12). The first points to edit are the black and white points, the top and bottom points of your data table. Click on the white point on the bottom left of the curve line. Its data values start at Input = 0 and Output = 0. Change these values to match your first data point

Figure 7-11 Switch curve direction. (A) Photoshop curve does from dark to light. Input and Output values shown in Photoshop units. Click the small arrow in the midtone to switch mode. (B) Photoshop curve does from light to dark. Input and Output values shown in percents. Use this mode to enter your curve data.

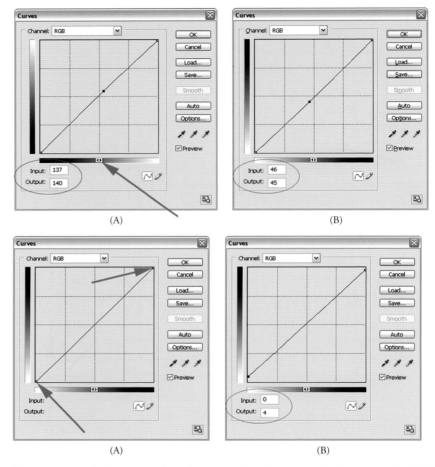

(A)

(B)

(A)

(B)

Figure 7-12 First and last points. (A) Starting black and white points at 0:0 and 100:100. Click the points to edit the Input and Output values. (B) Change the Input and Output values to match your first and last data points.

(Input = 0 and Output = 4 in the example table shown in Figure 7-10). Click the black point on the top right of the curve line. Its data values start at Input = 100 and Output = 100. Change these values to match your last data (Input = 99 and Output = 100 in the example table shown in Figure 7-10).

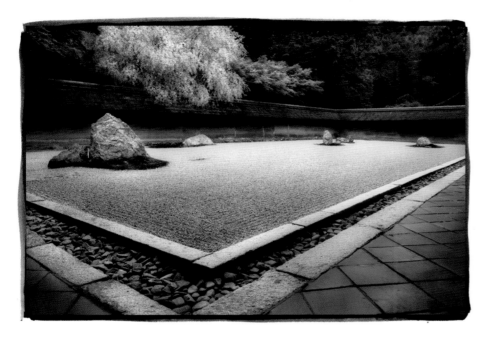

'This austerely elegant landscape was built in the 1500's. The name of the designer is unknown and he left no record of any intended meaning. The space invites meditation and introspection.'

Palladium

Image captured with a 4 × 5 view camera. No tripods were allowed so the camera was balanced on a daypack laid on the veranda. After scanning the film with an Imacon 646, extensive image editing was done in Photoshop. A correction curve was applied to the edited image file, the file was inverted to negative, and the negative was printed on Pictorico OHP. The digital negative was used to expose a sheet of Arches Platine coated with a pure palladium emulsion.

Ryoanji Garden 2005 Ron Reeder Final print, about 18 × 15 inches.

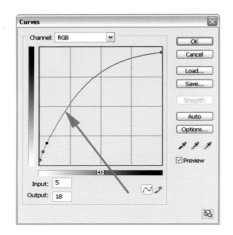

Figure 7-13 Adding data points. Click an open part of the Photoshop curve to add a new point, and enter the appropriate Input and Output data values.

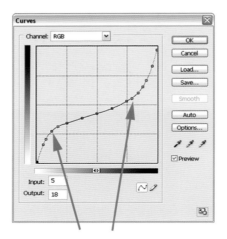

Figure 7-14 Data points at the ends of the curve. Place more points near the dark and light ends of the curve, where there is more change in the curve.

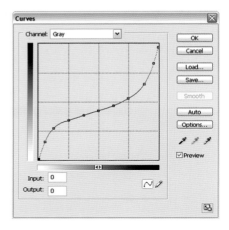

Figure 7-15 A good curve.

Now add the rest of your data points. Click on the middle part of the Photoshop curve where there are no data points. Start with the top most data point and merely type the Input and Output values into the dialog (Figure 7-13).

Then just click again on the curve to create another point and add another value, and so on, until you have a complete curve. It is useful to have more points near each end of the curve, where the curve changes most, and fewer points in the straight center section of the curve (Figure 7-14).

The curve should reduce the overall contrast of your image; it should be flatter in the middle than on the ends. If you have a curve that is steeper in the middle (i.e., looks like a traditional H&D curve), then you have the Input and Output values backward (Figure 7-15).

Now save your curve. Click the Save option in the Curves window and give the curve a name that is specific to your process (Figure 7-16).

Figure 7-16 Save the curve.

Now you can apply this correction curve to your original test image and run through the process again. You should have a resulting print image that looks fairly similar to the original test image on the computer.

Tweaking the Curve

The process for creating correction curves is fairly precise, but it is common that one or two data points are not exact. This is especially true for creating curves for alternative

Figure 7-17 Tweaking a curve. Corrections curves should be smooth. If a point appears to disrupt the curve, you may wish to tweak it to make a smoother curve.

processes where the emulsions may have some minor variability because they are hand coated. Correction curves should be fairly smooth. If a data point is inaccurate, it is usually obvious when looking at the final curve. A small 'tweak' to a data point will often make the final curve appear much smoother and will actually make the curve work better. Just look for the points that are obviously out of line.

Testing Correction Curves

Check to see if your new correction curve actually works. Open the original, unmodified step tablet image. Apply your new curve to this image, invert to make a negative, print it out as a digital negative, and print it on paper using the same process you used to derive the curve. Scan the printed step tablet and measure paired Input and Output values for several of the squares. If the correction curve was properly made, Input and Output values should be nearly identical this time around. If the paired Input and

Density Changes using a Digital Negative

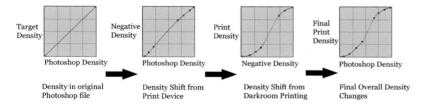

Target Density — Photoshop Density — Density in original Photoshop file

Negative Density — Photoshop Density — Density Shift from Print Device

Print Density — Negative Density — Density Shift from Darkroom Printing

Final Print Density — Photoshop Density — Final Overall Density Changes

Density Changes with Correction Curve Added

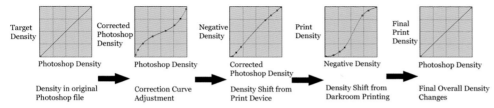

Target Density — Photoshop Density — Density in original Photoshop file

Corrected Photoshop Density — Photoshop Density — Correction Curve Adjustment

Negative Density — Corrected Photoshop Density — Density Shift from Print Device

Print Density — Negative Density — Density Shift from Darkroom Printing

Final Print Density — Photoshop Density — Final Overall Density Changes

Figure 7-18 How the correction curve affects the density changes when printing with digital negatives.

Output values are not close, you need to go back and correct your procedure before you can use the derived correction curve with any confidence. A common mistake is to perform a small part of your procedure differently; make sure you keep notes for your process so your can repeat it identically for each negative. The most common mistake is not to set the printer settings in exactly the same way for each negative.

Use this curve layer for all images for which you want to apply this particular process. Create a new curve for any new paper or chemistry.

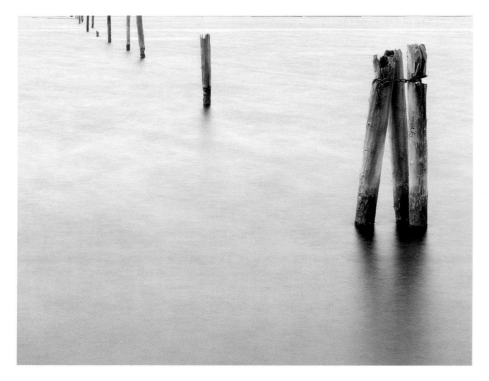

'This line of old harbor pilings created a strong abstract image over the water.'

Platinum/Palladium

This image was originally captured on to TMax 400 film using a view camera. The exposure was about two minutes long to create the soft texture on the water. The image was scanning into Photoshop and the contrast adjusted to maximize the contrast of the logs and soften the contrast of the water. A negative was printed onto Pictorico OHP film and contact printing onto a Platinum/Palladium emulsion on Arches Platine paper. The emulsion had about 20% Palladium to add just a touch of warmth.

Final print size, about 11 × 14 inches.

Line of Columns 2001 Brad Hinkel

8 monitor soft proofing

The Holy Grail in printing with digital negatives is to have the image on the computer screen match as closely as possible the image on the final print. Soft proofing can help us achieve this goal by configuring the image in Photoshop® to more closely match the look of the final print.

We need soft proofing because the computer screen image is assessed with two different types of sensors: the computer's eyedropper tool and your eyes. The computer's eyedropper tool will accurately measure the tonal values of the computer's virtual image. It is relatively easy to arrange it so that a tone measured by the eyedropper as 50% gray on the computer screen translates to a 50% gray tone on the final print. To do this, the eyedropper tool and a densitometer (or a scanner) are used to construct a correction curve, as described in Chapter 7, and apply the curve to correct for the tone distortions that occur in going from screen to print. The problem is that when we work on an image in Photoshop, we mostly use our eyes to judge when the image looks 'right' on the computer screen, and your eyes ordinarily do not sense tonal values the same way that the eyedropper does. Typically, the screen image is displayed in gray tonal values and has the full contrast range from screen black to screen white. But the printed image may often be rendered in tones particular to the specific process and has the contrast range from paper white through to maximum black for the process.

Figure 8-1 Comparison without soft proofing. (A) A palladium print. (B) The original image on a monitor.

(A) (B)

This can result in images that appear differently even though the correction curve accurately maps the Photoshop image onto the printed image (Figure 8-1).

As a result, we find ourselves in a frustrating situation where the image on the screen looks great and we apply a carefully constructed, mathematically accurate correction curve, but the resulting print still is too dark or too light. At that point the temptation is great to mutter a bit and then start empirically fudging the correction curve until a good-looking print is achieved. Empirical fudging has its place, but before resorting to that method, there is a more logical approach called 'soft proofing,' which adjusts the monitor image so that it more closely matches the final print. This makes it so what we see both on the final print and the image on the computer screen show the same tonal values and greatly increases our chances of making a good print on the first try (Figure 8-2).

(A)　　　　　　　　　　(B)

Figure 8-2　Comparison with soft proofing. (A) A palladium print. (B) The monitor image with soft proofing.

Basic Color Management

In order to properly setup soft proofing, you must first configure Photoshop for proper color management. Many people wonder why do color management for a system designed to create black-and-white prints. Some people have merely adjusted their monitor to make the images appear like the final print. But then everything you do on that monitor will match one specific printing process (and do you really want all your images to appear as palladium prints?). Go through the process of setting up a basic color management system and your final results will be much easier for both digital negatives and for other types of photo printing.

Color management is designed to make your computer system render images accurately. In particular, you want to calibrate (and profile) your monitor. The goal is to set the black and white end points on the monitor so that they do not clip either the highlights or the dark tones. And you want middle gray to be a relatively neutral gray, not reddish or greenish. The best way to calibrate your monitor is to purchase a monitor sensor specifically for this process; it is a good investment to help you ensure that, monitor is displaying an accurate version of your image.

If you do not want to purchase a monitor sensor, use the monitor calibration utility built into Macintosh® OSX or the Adobe Gamma® utility that comes with Photoshop for Windows®. These are the minimum starting point for calibrating your computer.

Once you have your monitor properly calibrated, it will accurately display the grayscale images from within Photoshop.

You must also configure Photoshop to properly render the grayscale images that are opened within it. We configure Photoshop to use a gamma of 1.8 to produce an image on-screen that better matches the contrast of the final printed images. Our test images and step tablets are all set to use this gamma value. To configure Photoshop, go to Edit > Color Settings in Photoshop and set the RGB working space to ColorMatch RGB and the Gray working space to Gray Gamma 1.8. Under Color Management Policies set the RGB and Gray space to convert to Working RGB or Working Gray spaces (Figure 8-3).

It is important that you use the appropriate color spaces for editing your images. If not, the color values (or density values for the Gray space) will no longer read properly. Any values that you read using the eyedropper would no longer be accurate. When you open an image that is not in the default working space (RGB or Gray), Photoshop will display a Profile Mismatch or Profile Missing message window; merely accept the default option to convert the image to the proper working space (Figure 8-4).

Box 8.1 AdobeRGB and sRGB vs ColorMatch RGB

If you are already familiar with color management, you may have set your color settings to use AdobeRGB or sRGB. We suggest that you use Color-Match RGB for digital-negative images, because it uses a gamma of 1.8, which matches the Gray Gamma 1.8 we recommend for grayscale images. It is possible to use AdobeRGB or sRGB color spaces for digital negatives, but these use a different gamma value. See the article on Gamma 2.2 on the Web site (www.digital-negatives.com).

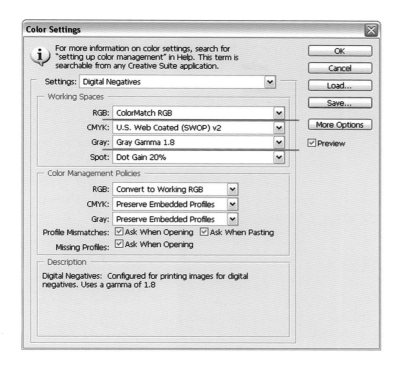

Figure 8-3 Color Settings window.

Figure 8-4 Profile Mismatch message window.

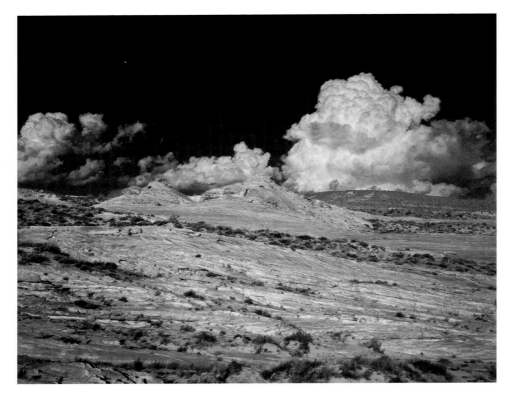

Valley of Fire 2002 Brad Hinkel

'The Valley of Fire in south-
ern Nevada is typically cap-
tured to show off the vibrant
colors. But after looking at
this image for some time, I
was more attracted to the
textures and rendered it in
black & white.'

Platinum

I captured the original image onto
4 × 5 Ektachrome 100 film in vibrant
color. I eventually converted the image
to black & white in Photoshop to
accentuate the texture of the scene. A
positive was printed onto Pictorico Hi-
Gloss White film to maintain as much
fine detail as possible and a contact
negative was made onto darkroom
film. (the white film maintains slightly
more detail than the OHP film). The
negative was contact printed onto a
Platinum emulsion on Arches Platine
paper. The emulsion used 100% plat-
inum to create the neutral almost cool
tone in the final print.

Final print size, about 11 × 14 inches.

Soft Proofing

Soft proofing is a relatively simple concept. First, we set up the computer so that the eye-dropper tool reads accurately and use that tool to construct an accurate correction curve. When that is done we are confident that tones measured by the eyedropper will be close to tones that show up in the final print. Then, to make our eyes read correctly, we place a Soft Proof adjustment layer on top of the image and arrange the adjustment layer so that densities of the image (as read by the eyedropper) appear as similar densities to our eyes. When that is done, we can turn on the adjustment layer to assess the image visually, or turn the adjustment layer off to assess tones mechanically with the eyedropper. Tones measured by either method then ought to show up pretty accurately in the final print. The steps for creating the Soft Proof adjustment layer are described in the next section, and the specific steps for using the Soft Proof adjustment layer are shown in the following section.

Creating the Soft Proof Adjustment Layer

You need to create a Soft Proof adjustment layer for each of your specific printing processes. We find that some processes have sufficient density and contrast that a properly calibrated monitor provides a sufficient soft proof, e.g., silver RC papers. But some processes result in such different color and contrast from the image on the monitor that a soft proof is very useful, e.g., palladium or cyanotypes. You need to create a different soft proof for each process that you use.

The following steps are used for creating a Soft Proof adjustment layer:

1. You need to create some sample prints to help create the soft proof. First, obtain a sample of the paper on which you will be making your final prints; this is the 'white' sample and will be used to adjust the white value for your soft proof.

Second, make a sample print of pure black for your sample process by merely exposing a piece of paper with the normal emulsion without any negative and developing it normally; this is the 'black' sample and will be used to adjust the black value for your soft proof.

2. Construct a correction curve specific to the printing process you intend to use. Open a grayscale step tablet, be sure that is has gray gamma 1.8 embedded (the eyedropper should read the stated gray tones correctly) and make a correction curve as described in Chapter 7.

3. Use this correction curve to make a few sample prints. Open an image file, work on it in Photoshop until it looks good on the screen, make a digital negative using the correction curve just derived, and make a print. Repeat this process for two more images. After drying, hold the prints up next to the computer screen and evaluate them. The prints will probably be consistently lighter or darker than the image on the screen.

 You should have five sample pages: a white sample, a black sample, and three (or more) sample images (Figure 8-5).

 Place these samples under a good proofing light adjacent to your computer monitor. You will be comparing these to images on the monitor.

4. In Photoshop, create an image that is half pure black and half pure white. Go to File > New. . . and create a relatively small image that is pure white, uses the color space you are using for your digital negatives (ColorMatch RGB), and is 16 bits per channel (Figure 8-6).

 Select the top half of the sample image and fill it with black. Use the rectangular marquee to select half of the image and use Edit > Fill (Figure 8-7).

 You now have a test image to match to the black and white sample prints.

5. Create a new Curves adjustment layer for the soft proof. Go to Layer > New Adjustment Layer > Curves and name the new layer 'Soft Proof' (Figure 8.8).

Figure 8-5 Set of test samples: white, black, and some images.

New

Name: Untitled-1	OK
Preset: Custom	Cancel
Width: 8 inches	Save Preset...
Height: 10 inches	Delete Preset...
Resolution: 30 pixels/inch	
Color Mode: RGB Color 16 bit	
Background Contents: White	Image Size:
	41.2M

Advanced

Color Profile: ColorMatch RGB

Pixel Aspect Ratio: Square

Figure 8-6 Create soft proof 1.

Figure 8-7 Create soft proof 2.

Figure 8-8 Create soft proof 3.

6. Now for the tricky part: to use the curves layer to match the paper white and the DMax of the print. In the Curves window, click the Options. . . button (this is for the Auto Color Options) (Figure 8-9).

Figure 8-9 Create soft proof 4.

In the Auto Color Correction Options window (Figure 8-10), you need to set the black and white target points to match the black and white sample images. Click in the Shadows field (Figure 8-10).

The Color Picker window will open. Pick a color that matches the black on the screen to the black sample print you made earlier (Figure 8-11).

Just experiment to make the two colors fairly close, then click OK to select this color for your black target. Now, repeat this for the white target color. Click the Highlights field in the Auto Color Correction Options window to open the Color Picker window. Pick a color that matches the white in the test image on the screen to the white sample print (Figure 8-12).

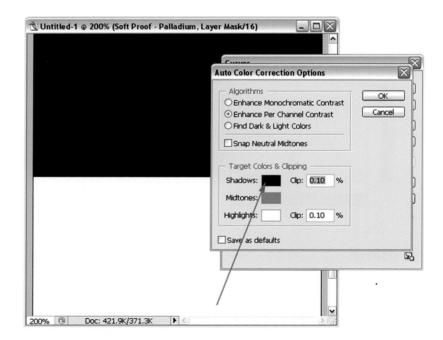

Figure 8-10 Create soft proof 5.

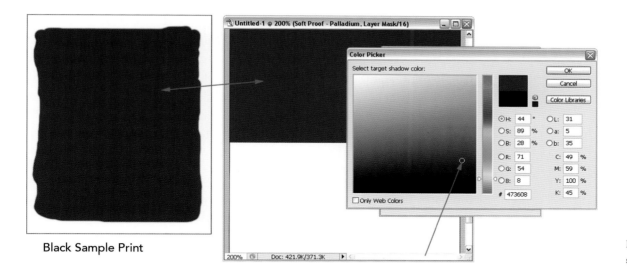

Black Sample Print

Figure 8-11 Create soft proof 6.

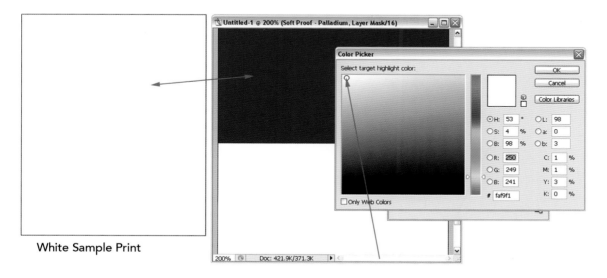

White Sample Print

Figure 8-12 Create soft proof 7.

Creating the Soft Proof Adjustment Layer 133

Click OK in the Color Picker window to select the color, and OK in the Auto Color Corrections Options window to set the target colors you selected. The correction curve should now make the test image white match the paper white sample print, and the test image black match the black sample print. You now have a basic soft proof curve. Click Save in the Curves window to save the curve, and name the curve 'Soft Proof' plus the name of your process (Figure 8-13).

This soft proof curve is often fairly accurate, but you should test it against the additional sample prints that you created.

7. To adjust the midtones, hold up one of the prints you have made alongside the computer screen. Open up the image file for that print in Photoshop, and create a new Curves adjustment layer for the image file. In the Curves window, click

Figure 8-13 Save curve.

Load to load the soft proof curve that you just saved. Before you close the Curves window, compare the print of the image to the image on screen (Figure 8-14).

8. There is a good chance that the two images will not match sufficiently well. The bright highlights and the dark shadows should match, but the midtones on the computer screen may be darker or lighter than those in the print. Grab the middle of the RGB curve and move it up or down to make the screen image look more like the actual print. You may find that simple lightening or darkening is not sufficient, but that you need to increase or decrease overall contrast to make the two images more closely match. When you have the best match you can achieve, make sure that you save the adjustment curve again (click the Save button on the Curves window) (Figure 8-15).

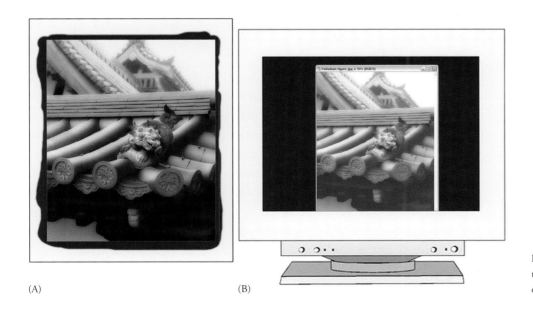

(A) (B)

Figure 8-14 Compare the densities of the two images. (A) The sample print. (B) The original image on a monitor.

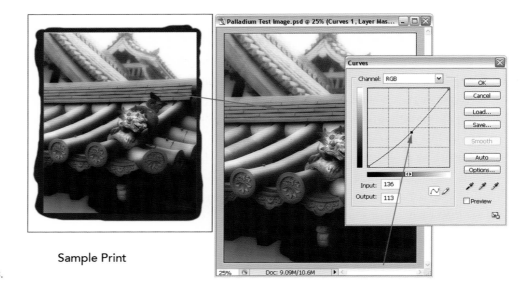

Sample Print

Figure 8-15 Create soft proof 8.

9. To fine-tune your soft proof curve, repeat the process with another test image. Look at a sample print under the proofing light next to your computer and open the same image file in Photoshop. Create a Curves adjustment layer above the image, and load the soft proof curve just created. Hold up the corresponding print alongside the computer image and compare them. Generally, you will not have to bother with the black and white end points this time, but you may find that the middle of the RGB curve needs tweaking to get the print and the screen image to match. Repeat this process for each of the other images you have printed. The intent is to eventually arrive at a general soft proof curve that works well for all images. Remember to save the soft proof curve file you created.

Using the Soft Proof

Use your soft proof curve as part of your normal printing workflow. Open an unedited image, make a Curves adjustment layer for it, and load the soft proof curve derived earlier. Now begin working on the image layer to make it look the way you want. If you wish to measure specific tones with the eyedropper (we find the eyedropper essential to accurately distinguish very light shades of gray), turn off the adjustment layer and measure away. When you want to assess how the overall image will look after being printed and dried, turn on the adjustment layer. For a lot of image editing, it works to leave the adjustment layer turned on, activate one of the underlying layers, and see directly how editing changes will affect the look of the final print.

When you get ready to print a digital negative from the edited image, turn off the Soft Proof adjustment layer. Otherwise, all your careful calibration goes out the window! This layer is designed to mimic the process on which you will be printing, but you do not want this mimic to appear on your printed negative.

Then print your image normally. Typically, you will be able to print your digital negatives while the image is in RGB mode even though it is a grayscale image; this works fine for the Epson printer drivers that are used in this book. But you may need to convert the image back to grayscale for printer drivers that are designed specifically for black-and-white printing, including the QuadTone RIP described in Chapter 10.

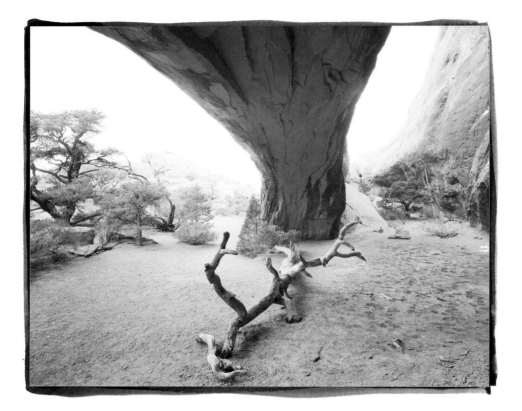

Navajo Arch 2005

Ron Reeder

'From this angle the arch looks like the underbelly of a great reptile.'

Platinum/Palladium

Photographed with a Linhof Technica view camera on 4 × 5 black and white film and scanned with an Imacon 646. A correction curve was applied to the image file which was then inverted and printed as a negative on Pictorico OHP with an Epson 4000 printer using the Quadtone RIP driver. The digital negative was used to expose a sheet of Arches Platine coated with a 1:1 platinum/palladium emulsion.

Final print, about 11 × 13 inches

9 about printers

The inkjet printer is at the heart of printing digital negatives. It is now practical to own a relatively inexpensive desktop printer that can make exceptionally good digital negatives for contact printing. The ability to print negatives quickly and easily from your own computer is one of the essential advantages of printing digital negatives.

An inkjet printer only has to accomplish two jobs to make it suitable for printing digital negatives: (1) it must print smooth tones with a minimum of printer artifacts, and (2) it must be able to lay down enough ink so that the negative will be able to print pure white in the photographic process of your choice. We expect that essentially any modern photo-quality printer will meet these criteria. Why then do we only mention Epson printers in this book? Simply because Epson printers at present dominate the market place and our experience has taught us that they are very good for many different types of photo printing, including black and white, color, glossy, matte, and digital negatives. We are sure that most inkjet printers on the market can produce good inkjet negatives, but we simply do not have the time or resources to try out all these printers and determine the 'best.'

Our Recommendations

If you are on a budget, we recommend finding a good used Epson 2200 (Figure 9-1). (The Epson 2200 is known as the 2100 throughout most of the world). These older machines are available rather inexpensively, yet they have excellent print heads and will make negatives up to 13 × 19 inches in size. They can be driven with either the Epson

Figure 9-1 Epson 2200.

Figure 9-2 Epson 4000.

driver or with the QuadTone RIP. Support for the Epson 2200 with the QuadTone RIP makes the Epson 2200 an excellent printer for digital negatives; just wait and see what the QuadTone RIP can do in Chapter 10. The Epson 2200 can also produce excellent black-and-white and color prints on a wide range of matte or glossy surfaces, although it can take some work to get these excellent results. The Epson 2200 has been the workhorse for many a digital darkroom for the past several years. It was an excellent printer in recent years, and still is one today, even though it has been replaced by newer printers.

The Epson 4000 (Figure 9-2) is essentially a larger version of the Epson 2200 printer with three notable improvements; it prints on paper up to 17″ wide making it easy to create 16″ × 20″ digital negatives; it supports much larger ink cartridges and thereby reduces the ink cost per print; and finally, the Epson 4000 has both the Epson Photo Black and Matte Black inks installed at the same time eliminating the need to change cartridges when switching from Matte to Glossy media. It seems that used Epson 4000 printers are even a better deal this year than used Epson 2200 printers. If you have the space to put this printer in your digital darkroom (it is a big printer), then you should consider an Epson 4000. Both Ron and I use the Epson 4000.

If you spend more money and purchase one of the latest models (either the 2400 or the 4800) we expect you will not see much difference in your digital negatives. But the newer models do have some nice improvements. These newer printers are significantly faster than the previous models. The printer drivers for the Epson 2400 and 4800 make it easy to print excellent color and black-and-white images and these new printers use the newer K3 inkset, which apparently yields improved digital prints in both color and black-and-white.

You may have a good reason to use a different printer to print your digital negatives, and likely your printer will work fine. Go ahead and try it out to create your negatives. The curves and profiles that are available on the Web site for this book (www.digital-negatives.com) are designed for the Epson 2200, 4000, and 2400 printers. We also intend on adding support for some additional printers. Check out the Web site to see if we have added profiles or curves for any other printers.

Printer Inks

Printer manufacturers have spent a lot of effort recently to come up with inkjets that will make light-stable, long-lasting prints. For digital negatives, however, archivalness seems a nonissue. You will want to safely archive your negatives and/or digital files, and you will certainly want your final prints to be archival. But the negatives do not have to be especially long lasting since it is almost easier to print a new one on demand than to figure out how to store all the old ones.

Figure 9-3 Epson R2400.

But for printing digital negatives, our main concern about ink is the ink density. Most inkjet printers do produce a dense-enough black to create digital negatives for almost all photographic processes, but not quite. The pure palladium process that we teach in Chapter 5 requires a negative with a fairly broad density range. The Epson photo printers that we recommend in this chapter therefore have two additional advantages for digital negatives: the black ink used by these printers is sufficiently dense for all the processes that we have tried (including pure palladium prints), and these printers all use two (or more) densities of black ink.

Let's talk a bit about the Epson inksets. The previous Epson pro photo printer models (such as the 2200, 4000, and 7600) use the Ultrachrome inkset, which consists of seven different inks in the printer, including two black inks — a light black and a dark black. The dark black ink comes in two varieties, Photo Black and Matte Black. To change between Photo Black and Matte Black you must change cartridges (except on the 4000, where all eight inks are installed all the time). With the Epson driver, all ink colors are used, even when you are only printing a grayscale negative. With the QuadTone RIP, we use only light black and dark black. The fact is that either photo black or Matte Black ink can print the darkest black you will ever need in a digital negative. So to avoid switching cartridges as much as possible, we have chosen to stick with one dark black ink, i.e., Matte Black. This approach works fine with the QuadTone RIP driver, where we can directly control the ink settings. With the Epson driver, however, once you have loaded in Matte Black ink, you can only choose matte

paper media settings. And these settings do not put down enough ink for processes like palladium printing that need a rather contrasty negative. So, to make palladium-printing negatives on the 2200 and the 4000, we reluctantly went to photo black ink and a more glossy media setting that would lay down enough ink.

Newer Epson printers use the K3 inkset, which consists of eight inks in the printer and the choice of switching cartridges between Matte Black and Photo Black for the dark black ink. The K3 inkset also has an extra black ink, a light-light black. With the K3 inkset, we have been able to make all profiles using Matte Black. This is fortunate because K3 Photo Black for some reason will not print very darkly on Pictorico OHP. With the QuadTone RIP driver, we have not found much use for the K3 light-light black and turn it off entirely, using only two black inks in these printers: Light Black and Matte Black.

If you look at a digital negative printed on Pictorico OHP and destined to make a palladium print, you will notice that it does not look very contrasty. How then is it possible to use such a negative to make a brilliant print on such a low-contrast emulsion as pure palladium? The answer is that Epson inks in general absorb more ultraviolet light than visible light. Thus they can have an excellent contrast range in the ultraviolet and still look rather anemic in visible light. A negative must have a density around 3.2 (OD) optical density units (in the ultraviolet) in order to print pure white on palladium. Epson inks can easily achieve densities of 3.8 OD and higher.

About Media

Digital negatives can also be printed onto just about any medium, including paper. Digital negatives printed onto paper will show the texture of the paper on the final print, because light will pass through the paper (and the paper texture) when exposing the final print, reminiscent of printing through paper in the traditional silver darkroom.

For most digital negatives, we suggest that you print your images onto a polyester film, either a white film or a transparent film.

White film is sold or marketed by a number of inkjet printer companies, including Pictorico, Ilford, Oriental, Olympus, and others. Make sure that you use a white film that is designed for inkjet printers or the ink may run on the film during printing, making quite a mess. The white film produces an extremely sharp image and is therefore ideal for printing digital negatives. But there is one serious problem. As far as we know, all of the manufacturers of the polyester white film add optical brighteners to the white film to make it appear super white. These brighteners make the white film opaque to ultraviolet light and therefore useless for most alternative processes. The optical brighteners make the white film almost useless for digital negatives. But the white film media do successfully pass visible light and are therefore excellent for printing digital negatives for any process that is sensitive to visible light, including silver paper and Daguerreotypes. We have used Pictorico High-Gloss White Film to make a large number of prints onto silver papers as well as a few Daguerreotypes, and we recommend this film.

Figure 9-4 Pictorico White Film.

Transparency film is very similar to the white film, but is well, it's transparent. Transparency film does not have the problem of optical brighteners found in the white film and passes UV light very well. Most transparency films would likely work for digital negatives, but these transparency films do not produce extremely sharp images. Pictorico OHP transparency film is a notable exception and produces very sharp images. There is some debate about whether the white film or transparency film creates sharper negatives, but frankly, the Pictorico OHP transparency film is sharp enough for any hand-made alternative process. We recommend using the Pictorico OHP film for any alternative process that is sensitive to UV light.

Figure 9-5 Pictorico OHP Transparency Film.

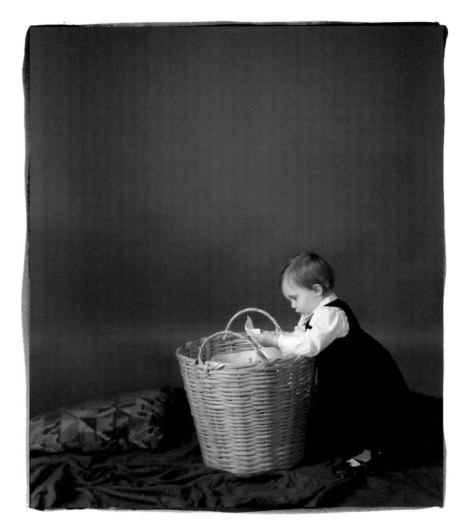

'She could not walk, but crawled rapidly and non-stop. The only way to keep her in the plane of focus was to give her something to satisfy her curiosity.'

Palladium

Taken with a medium format Mamiya 7 using Kodak Tmax 100 roll film. The camera was slaved to an electronic flash in a large soft box. The negative was scanned with an Imacon 646 scanner, edited in Photoshop, and a mild correction curve was applied to the image file. The image was then inverted and printed as a negative on Pictorico OHP using an Epson 4000 printer and the Quadtone RIP driver. Most of the image correction was applied as a custom Quadtone profile in the driver. The digital negative was used to expose a sheet of Arches Platine coated with a pure palladium emulsion.

Final print size, about 15 × 18 inches.

Kendall age 13 months Ron Reeder

10 using the QuadTone RIP

QuadTone RIP (QTR) is a printer driver originally developed to improve the ability of Epson printers to print black-and-white prints. Incidentally, it also turns out to be an excellent driver for printing digital negatives because it allows you to place all (or nearly all) correction down in the driver itself, rather than placing it on the image file (as we taught you to do in earlier chapters). To understand why this is a good thing, we will begin with a discussion of printer drivers and what they do. Then we will tell you how to download and install QTR and how to use it to print a digital negative. When you print with QTR you must select a QTR profile specific to the printer model, media type, and inkset you are using. To help you get started we have made some custom QTR profiles for digital negatives and will show how to download, install, and work with these profiles. Finally, for ultimate control we describe how to make your own custom QTR profiles.

One snag in learning to manipulate QTR profiles is that the user interface on the Mac is completely different from the interface on the PC. All the same functionalities are present on both machines, but they look quite different. Therefore, we have written parallel sets of instructions for altering QTR profiles. Three sections in this chapter are clearly identified as MAC; comparable sections containing instructions for using the PC interface begin on page xxx.

Working with QTR profiles will probably not be everyone's cup of tea because it requires further descent into the underworld of computer wizardry. However, if you

are looking for the ultimate in print quality you will want this tool and will find it worth the effort to learn how to use it.

A Brief Introduction to Printer Drivers

When you purchase a desktop inkjet printer, it comes bundled with software called a 'printer driver.' (The printer driver is also sometimes called a RIP, or raster information processor.) The job of the printer driver is to tell the print head how to lay down ink in response to an image file sent from a computer. The driver that came with your printer is not ideal for printing digital negatives, partly because most drivers have been optimized for printing color with monochrome printing as an afterthought. But the real problem is that the driver that came with your printer is a proprietary piece of software that gives the user only limited access to the driver controls. Instead, what is offered is a series of presets, often called 'media' choices. Each preset attempts to match ink deposition to the needs of particular printing surfaces or 'media.' There is no way to tell what the actual ink settings are for a particular media type, and chances are that none of the presets match your requirements for printing digital negatives; for example, for printing a negative on Pictorico OHP that is destined for making a palladium print.

You can purchase third-party printer drivers that allow more control over the ink settings. The bad news is that most of these drivers are expensive, often costing more than the printer itself. QuadTone RIP is the exception. It was developed by Roy Harrington as shareware. You download it for free and try it out. If you decide to use it, you send Roy $50. It is a bargain. (Disclaimer: neither of the authors of this book has any financial interest in QTR).

For digital negatives, the traditional way to correct for deficiencies in the driver's ink presets, or for any other distortion in the printing process, has been to make a correction curve and apply it to the image file before it is sent to the printer (as described

in Chapter 7). A correction curve applied to the image file must do two jobs, both of which are better accomplished in the driver.

1. The first job is to adjust the overall contrast of the negative to match the contrast range of the sensitized emulsion you intend to print on (in other words, set the black and white end points of the negative). A correction curve applied to the image file will accomplish this job by distortion of the image to control maximum and minimum ink deposition. In QTR you do this job in two steps by (1) choosing a minimum exposure that makes maximum black on the print, and (2) varying the ink limit adjust until the right amount of ink is laid down on the negative to create pure white on the final print. Doing this operation in QTR involves no distortion of the image file whatsoever.

2. The second job is to control ink deposition so that all the midtones of the image are faithfully reproduced in the final print. Again, a correction curve does this by controlled distortion of the image file. The same job can be done in QTR by directly regulating ink deposition in the midtone ranges without messing with the image file.

Will You See a Difference in Print Quality if You Sse QTR?

The short answer is 'yes,' but the improvement may be subtle. Using QTR prevents nearly all distortion of the image file and thus nearly eliminates any chance of posterization in smooth tonal transitions. But, remember, we told you that editing the image file in 16-bit depth also suppresses posterization, even when the file must be distorted by a correction curve. So, working in 16-bit depth in addition to using QTR really, really suppresses posterization. This is a good thing, but the net improvement to your image may be hard to see. The place where QTR most seems to improve things is in

controlling local contrast of the lighter tones, especially in prints using a very low contrast emulsion such as pure palladium. Palladium prints require a fairly extreme correction curve. The part of the curve that controls the high values typically rises sharply for a few percent then becomes very shallow through the light quarter tones and midtones before rising steeply to pure black. The light part of the curve is difficult to fine-tune because minor changes in the curve make overlarge and difficult-to-predict changes in the print. Skin tones from a correction curve negative often seem duller and less lively than skin tones from a QTR negative.

The bottom line is that using QTR will improve your prints, but the amount of improvement will depend upon your subject matter and the type of printer you happen to use. A simple correction curve on the image file will probably get you at least 90% of the way to an optimal print. Whether or not squeezing out that last few percent of image quality is worth the trouble of learning to manipulate QTR is a decision you will have to make for yourself.

Downloading and Installing QTR (Mac)

These are instructions for the Mac; comparable PC instructions are available on page xxx.

Go to the QuadTone RIP Overview Web site (www.quadtonerip.com) and on the left hand side of the page click Downloads. A new page appears where you can choose to download either the Microsoft Windows® or Apple Macintosh® version of QTR. Click the Mac download option and three new icons will appear on your computer desktop. Two of these icons have names that end in either .dmg.gz or .dmg; ignore them. The third icon looks like a small hard disk drive called 'QTRIP2.3.' Click this icon. It will open with contents as shown in Figure 10-1.

Figure 10-1 The QuadTone RIP Installer (Mac).

Installation of QTR proceeds in several steps. First, you install the basic program. Click the orange box icon 'Install-QTR-2.3.4.pkg' and follow the directions. Once the basic program is installed, make a new folder on your desktop named 'QTR Tools.' From the QTRIP2.3 window, drag the Tutorial.pdf plus folders labeled 'Curve Design' and 'Profiles' over into the new QTR Tools folder. These items will be useful later on. Now you can throw away the .dmg.gz and .dmg icons as well as the QTR2.3 icon to clean up your desktop.

Once the basic program is installed, you must install QTR profiles specific to the Epson printer and inkset you are using. You will probably want to install all the standard

profiles available in the QTR download. These profiles allow you to make high-quality black-and-white prints on common digital printing papers and are useful whether or not you ever use QTR to print digital negatives. To install these profiles, first make sure your printer is connected to the computer (in our experience the printer must be connected by a USB cable, not a Firewire cable, and the connection must be direct to the computer or via a powered USB hub) and the printer is turned on and ready to print. Now go to your newly created QTR Tools folder, find the Profiles folder, and open it. You will see a lot of folders named for various printer and inkset combinations. Select the correct folder for your printer and inkset (for example, if printing with the Epson 4000 and Ultrachrome inks, choose the folder labeled '4000-UC'). Open the folder and search for the installation icon. Again, if you are printing with an Epson 4000, the installation icon will be named 'Install 4000.' Click the Install icon and the proper QTR profiles will be installed. Do not click the Install icon with .ipp after the printer name unless your printer is on a network.

If you wish to print digital negatives you will need to install additional QTR profiles customized for each printing process you intend to use. Some custom QTR profiles are available on our Web site (www.digital-negatives.com) on the QuadTone RIP page. To install one of our profiles, first make a new file folder on the desktop named 'Install Script.' Then go to the Profiles folder (remember, you put it in the QTR Tools folder), find the installation icon for your printer (i.e., something like 'Install 4000'), and make a copy of it (click the icon once to highlight it, then in Finder go to File > Duplicate to make a copy). Drag the copy of the Install icon into your newly created Install Script folder. Next, go to our Web site, download the QTR profiles you want, and place them in the Install Script folder as well.

Note: Before installation all QTR profiles have icons that look like a small page of text with a corner turned down. You will notice that some of the custom QTR profiles on our Web site also have a companion, similarly named icon, but the icon looks different and the file name ends in .acv. These companion .acv files are standard Photoshop®

correction curves just like the ones we taught you to make in Chapter 7. You should download both a QTR profile and its companion .acv file at the same time, and they can both be stored together in the Install Script folder. We will describe how to use the .acv files a bit later on.

Now, with the printer connected and turned on, double click the copy of Install Script. A window will appear showing all the profiles installed and your custom profile(s) should be among them. Finally, quit Photoshop and then restart the program. The custom profiles should now be available for printing, which we will describe next. Just to be organized, you might want to store the Install Script folder inside the QTR Tools folder.

If you ever want to uninstall a QTR profile, open the QTR Tools folder, find the Curve Design folder, and within that folder open the Curve Dropbox folder. Inside you will see folders for each of the QuadTone printers you are using. Open the correct printer folder, find the QTR profile you want to delete, and drag it to trash. The next time you run Install Script, and quit/restart Photoshop, the offending profile will be uninstalled and deleted. You cannot delete installed profiles from any place other than the Curve Dropbox.

QTR does not displace the normal Epson driver. Instead, QTR is installed alongside the Epson driver and you have a choice of driver to use each time you print. Thus it is easy to switch between QTR (for high-quality black-and-white printing or digital negatives) and the Epson driver (for color printing) without changing the inkset.

And, do not forget to send Roy $50.

Printing a Digital Negative with QTR (Mac)

The QTR user interface is similar to the Epson driver interface. To print a digital negative, return to Photoshop and first go to File > Page Setup. In the printer list, once

you have installed QTR, you should find an option to choose a QuadTone printer (i.e., Quad2200, Quad4000, etc). Then choose paper size and orientation. Note that QTR gives you the useful option of actually centering the image on the page, something Epson does not do. Go to File > Print with Preview. Check that the image is correctly sized and oriented on the page. Under 'Color Management,' look at the Options group box. In this box, under Color Handling, choose 'No Color Management.' This ensures that neither Photoshop nor the printer will color-manage the image as it is sent to the printer (we want our custom QTR profiles to do all the 'color management'). Click Print, and the Print window will open; check that the QuadTone printer is still the selected printer and set Presets to 'Standard' (later you may want to save some custom presets for making negatives). Under Copies and Pages you should now be able to select 'QuadTone RIP.' This will cause the QTR Print window to open and it will look similar to what you see in Figure 10-2.

QTR Dialog Window Set for UC Pictorico

Starting from the top, the first setting you need to worry about is Feed. Choose the manner in which you intend to feed your print media into the printer (roll feed, sheet feed, etc). The Curve 1 and Curve 2 boxes offer the option of setting the driver to use any of the installed QTR profiles. If you were making a regular inkjet print on Epson Enhanced Matte paper, for example, you could select a 'Warm Enhanced Matte' profile in Curve 1 and a 'Cool Enhanced Matte' profile in Curve 2. Then in Tone Blend you could choose how to blend the two profiles to achieve a large range of subtly different print tonalities. For printing digital negatives, however, you will select a custom QTR profile in Curve 1, select 'None' in Curve 2, and set Tone Blend to 100-0.

For the Epson 4000 you will be offered a choice of Photo Black or Matte Black ink. Choose Matte Black because that is the ink we used in making custom QTR

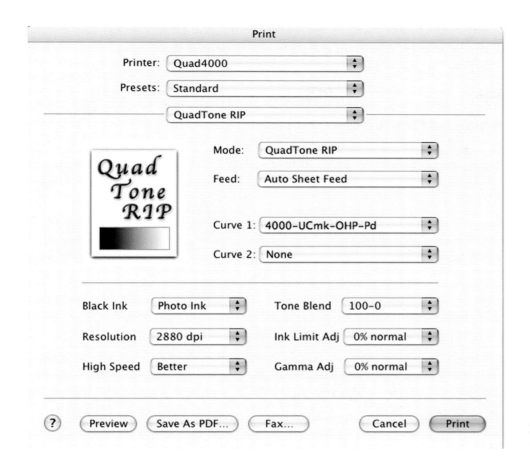

Figure 10-2 QuadTone Rip printer setup (Mac).

profiles for that printer. With other printer models you will have to switch cartridges to select a black ink. Be sure to use the same ink that was used when making the profile you intend to use. Resolution should be set as high as the printer will go, 2880 dpi if possible. Speed should probably be set to 'Better' (i.e., slower), although some newer

printers seem to work well at the 'Faster' setting. Ink Limit Adj and Gamma Adj should both be set to '0%.' At this point you could load in a sheet of Pictorico OHP, click Print, and print out a digital negative.

Testing and Fine-Tuning a QTR Profile

At this point you should check to see how well the QTR profile you have downloaded is actually working to linearize tones. Open a grayscale step tablet, invert it to negative, and (assuming you are going to make a palladium print) print the image onto a piece of Pictorico OHP using QTR and all the settings mentioned earlier, including a QTR profile designed for making palladium negatives. Using this negative, make a palladium print, clear, and dry it. Scan the dried print with a flatbed scanner and use the scanned image to measure Input and Output values for the various steps of the grayscale (same procedure as in Chapter 7). If the QTR profile worked perfectly, then every Input value should be paired with a nearly identical Output value. If the Input/Output values do not match, then there is still some uncorrected tonal distortion in the printing process. At this point the easiest way to correct for this residual distortion is to use the paired Input/Output values you have just measured to create a correction curve to be applied to the positive image file before sending it to the printer (just as we taught you in Chapter 7).

Now here is our dirty little secret: several of the QTR profiles we have supplied to you on our Web site are not capable of completely linearizing the grayscale. To fine-tune these profiles to complete linearization we have already made a companion correction curve, specific to each QTR profile that needs it, to be applied to the positive image file. That is the companion .acv file that you downloaded earlier, along with the QTR profile. For those QTR profiles that need it, you can use our companion correction curve or you can make your own from the data you have just measured.

How to Create and Modify your own QTR Profiles

Now, for the truly hard-core printer, here is how to make your own QTR profiles. To demonstrate we will make a profile for the Epson 4000 that is designed for negatives intended to print on a palladium emulsion. We will proceed according to the following steps:

1. Open a pre-existing QTR profile and rename it.

2. Change numerical values in the profile according to educated guesses (we will help with the guesses) and delete functions you do not need.

3. Use the modified profile to determine the Default Ink Limit. This determines the minimum amount of ink deposition needed to make a negative that will print pure white on a palladium emulsion.

4. Use GRAY HIGHLIGHT, GRAY SHADOW, and GRAY GAMMA to adjust the midtones so that they print with approximate linearity.

5. Use GRAY CURVE to complete the linearization process.

6. Test linearization ability of the final profile and, if necessary, make a companion .acv correction curve to be applied to the image file.

Step 1: Open and Rename a Pre-existing QTR Profile

Open the QTR Tools folder, then open the Profiles folder and the folder for your printer and inkset, and locate the QTR profile for Epson Enhanced Matte-warm (for the 4000 this profile is abbreviated UC-EenhMatte-warm). This is the simplest profile in the set because it uses only Matte Black and Light Black inks, which are all we

need for printing digital negatives. Make a copy of the Enhanced Matte-warm profile, rename the copy UCmk-Pict-4000-Pd-1, and drag the renamed copy into the Install Script folder you created earlier.

Step 2: Alter the Pre-existing Profile According to 'Best Guesses'

Double click the 4000-UCmk-OHP-Pd profile and open it. You are looking at a 'QuadTone RIP curve descriptor file' written as a text file. As we work through the editing process, you might want to refer to Figure 10-3. This figure shows the entire text file after all the following edits have taken place.

The first thing to notice is that many of the lines of text begin with a # sign. A # sign inactivates all instructions in that line. You can read the line for your own information, but it delivers no message to the printer. Typing a # sign at the beginning of a line is a way to leave messages for later users of the profile or to turn off a line of instructions without deleting it. The second line of text reads 'for 7600 or 9600 with ultrachrome inks.' This line is evidence of the fact that writing QTR profiles has been a cottage industry with many individual users contributing profiles for specific printers as they feel moved to do so. As long as the profiles work, no one feels the need to come along and edit them all for consistency or to remove evolutionary detritus. The line is turned off anyway, so ignore it.

Continue down to the line that reads GRAPH_CURVE = NO. Delete the NO and type in YES. Now each time you install this profile a graph will be created showing the distribution of all the inks used by the profile. You can learn a lot about how the printer uses its inks by looking at these graphs.

N_OF_INKS = 7: This line specifies the maximum number of inks your particular printer can use at one time. For the Epson 4000 the number is seven (for the 2400 the number is eight).

```
# QuadToneRIP curve descriptor file
#
# for 4000 with matte black and ultrachrome inks
#

PRINTER=Quad4000
CALIBRATION=NO
GRAPH_CURVE=YES

#
# number of inks must be 4, 6, or 7
# the ink limits are percentages
#   usually they are all the same but they can be individually set
#

N_OF_INKS=7
DEFAULT_INK_LIMIT=70

LIMIT_K=
BOOST_K=0
LIMIT_C=0
LIMIT_M=0
LIMIT_Y=0
LIMIT_LC=0
LIMIT_LM=0
LIMIT_LK=

#
# Describe Usage of each Ink: K,C,M,Y,LC,LM,LK
#   All Inks of Printer must be listed
#

#
# Gray Partitioning Information
#

N_OF_GRAY_PARTS=2
GRAY_INK_1=K
GRAY_VAL_1=100

GRAY_INK_2=LK
GRAY_VAL_2=38.5

GRAY_INK_3=
GRAY_VAL_3=

GRAY_INK_4=
GRAY_VAL_4=

GRAY_INK_5=
GRAY_VAL_5=

GRAY_INK_6=
GRAY_VAL_6=

GRAY_INK_7=
GRAY_VAL_7=

GRAY_HIGHLIGHT=0
GRAY_SHADOW=10

GRAY_GAMMA=0.9
GRAY_CURVE="0;0 1;10 4;20 8;30 15;40 50;70 87;90 93;94 97;97 100;100"
```

4000-UCmk-OHP-Pd.txt

Figure 10-3 The QTR Profile File (Mac).

DEFAULT_INK_LIMIT = 70: This number determines the maximum amount of ink the printer can lay down. We want the maximum amount of ink to be just enough to print as pure white on a palladium emulsion. For the 4000 the number is about 70.

LIMIT_K = : Leave this number blank. This allows the ink limit for Matte Black to be determined by the DEFAULT INK LIMIT.

BOOST_K = 0: When printing on paper a digital printer often has trouble laying down enough ink to make a really good maximum black. The BOOST function augments ink deposition in the darkest areas to help solve this problem. Generally we do not need BOOST when making digital negatives so set it to 0.

We will not use any of these inks so set them all to 0:

- LIMIT_C = 0
- LIMIT_M = 0
- LIMIT_Y = 0
- LIMIT_LC = 0
- LIMIT_LM = 0
- LIMIT_LK = : Leave this number blank so that the ink limit for light black will also be controlled by the DEFAULT INK LIMIT.

N_OF_GRAY_PARTS = 2: For the Epson 4000 we will use only two 'gray' inks, Matte Black (K) and Light Black (LK). So the number of gray parts equals two. For printers like the Epson 2400, which offer the possibility of three black inks (K, LK, and LLK), we will also only use only two (K and LK).

GRAY_INK_1 = K: The first 'gray' ink is the Matte Black or K ink.

GRAY_VAL_1 = 100: The K ink is always set to 100%.

GRAY_INK_2 = LK: The second gray ink is Light Black or LK ink.

GRAY_VAL_2 = 38.5: This number is the percent of K ink the printer would have to lay down to create the same optical density as 100% LK ink deposition. Tools and instructions for determining this number are included in the QTR download package and are not terribly difficult to use. The catch is that for making digital negatives, at least those negatives destined for printing processes that use ultraviolet light, you really need a densitometer that reads in the ultraviolet to accurately read the relevant densities. The Xrite model 361T will read both ultraviolet and visible densities; currently you can find a used unit on Ebay for prices ranging from $200 to $500. Fortunately, this number is a constant for a given printer-inkset-substrate combination. For printers that use the Epson K3 inkset (R2400, 4800, etc), we use a value of GRAY_VAL_2 = 32.5.

The GRAY_INK and GRAY_VAL numbers for the remaining inks can be left blank since we will not use any of them.

The contrast of a digital negative is adjusted by setting the DEFAULT INK LIMIT (provisionally set at 70 for now). The midtones of the negative are controlled by a combination of four functions, GRAY HIGHLIGHT, GRAY SHADOW, GRAY GAMMA, and GRAY CURVE. Settings for these functions must be determined empirically, but there is logic to the process and we can give you some starting numbers that may save time.

GRAY_HIGHLIGHT = 0: This function primarily affects light tones in the negative (dark tones in your print, of course). Think of it as grabbing a Photoshop curve in the light tone region and pulling it up or down. Increasing GRAY HIGHLIGHT makes negative light tones lighter; decreasing it makes the light tones darker. We find that palladium negatives generally need GRAY HIGHLIGHT set at 0, which is as low as it can go.

GRAY_SHADOW = 10: Primarily affects dark tones of the negative. Higher numbers lighten the dark tones, lower numbers darken them. A setting around 10 works for palladium negatives.

GRAY_GAMMA = 0.9: Primarily affects the midtones. Higher numbers lighten, lower numbers darken. This is a powerful function and increments of 0.1 have a significant effect. When typing this number, remember to always add a 0 before the decimal point if the number is less than 1 (otherwise the profile will not install).

To summarize:

GRAY HIGHLIGHT, SHADOW, and GAMMA: If you increase a value negatives get lighter and the prints get darker.

GRAY_CURVE =: For now, type a # sign in front of GRAY CURVE to turn the function off. We will turn it back on and use it later.

All other lines of text below GRAY CURVE are not needed for making digital negatives. Delete them.

Step 3: Determine the Default Ink Limit

You have already named your modified profile 'UCmk-Pict-4000-Pd-1.' Now save it and close it. With printer attached and turned on, double click the Install 4000 icon. The profile should install and a window should appear showing all the installed profiles, including your new one. And, if you typed YES after GRAPH_CURVE = there should be a curve at the top of the window showing the distribution of both the K and LK inks as specified by your new profile. To complete installation, quit and then restart Photoshop.

Open a grayscale step tablet, flip it horizontal, invert to negative, and print the negative on a piece of Pictorico using your new profile. Coat a piece of paper with palladium emulsion, and use the negative to make a print. Use the basic exposure time determined as we told you back in Chapter 6. When exposing the print, lay a piece of completely opaque black plastic so it just overlaps the region of the print that should be pure white.

After processing and drying, examine the boundary between the area covered by the plastic and the 'pure white' area of your print. For palladium prints we prefer just a hint of tone in the 'pure white' area. Such tone reads as pure white in most prints and prevents clipping of high values by slight over deposition of ink. If you need to change the ink limit, rename your profile with a new consecutive number, open it, change the DEFAULT INK LIMIT value, save and reinstall the profile, and test it again.

Step 4: Roughly Linearize the Midtones Using Gray Highlight, Gray Shadow, and Gray Gamma

Look at the print made from the negative where the ink limit was correctly set. In addition to a pure white patch at 0% black, you would like to also see some separation across the entire tonal range. Specifically, you would like to see a detectable difference between 0 and 5% black as well as a difference between 90 and 100% black. For palladium prints we often find that at this point the light print tones are too light and the dark tones are too dark. Generally, light print tones can be darkened by increasing GRAY SHADOW (remember, increasing GRAY SHADOW lightens tones in the shadow region of the negative, which means darkening tones in the light region of the print). Conversely, dark print tones could be lightened by decreasing GRAY HIGHLIGHT. But we have already set GRAY HIGHLIGHT to its minimum, which is 0. Fortunately, we can also lighten print dark tones by decreasing GRAY GAMMA, hopefully without at the same time throwing the light print tones too much out of whack. As you can see, there is some trial and error in determining these settings, and it can be difficult to keep one's head straight while converting back and forth between negative and positive space. If you can find a pre-existing profile, made for conditions similar to the conditions you want to use, it often helps to use numbers from that profile as a starting point for your own trials. We

will use GRAY CURVE to complete the linearization process, but GRAY CURVE needs the tonal scale to be in rough linearity before it can work its magic.

Step 5: Complete Linearization with Gray Curve

Make a negative of the grayscale step tablet using a QTR profile with the correct ink limit and the best trial-and-error settings you have for gray highlight, shadow, and gamma. Make a print from this negative, dry it, and scan it. Using measurements from the scanned image, make a table of Input/Output values as shown in the first two columns of Figure 10-4. We will use these paired Input/Output values to generate values to insert into GRAY CURVE.

Input	Output		Out(sc) In(cc) Input (neg)	Output (neg)
0	1		100	99
7	1		93	99
10	2		90	98
15	4	→	85	96
30	12		70	88
50	36		50	64
70	69		30	31
90	95		10	5
100	99		0	1

Figure 10-4 Corrected Curve Data for QTR Gray Curve settings.

Corrected Curve Data for QTR GRAY CURVE Setting

First we must transform the Input/Output values from positive space into negative space. Take each number in the Input column, subtract it from 100, and write it down in a new column headed 'Input(neg).' Similarly, take each number in the Output column, subtract it from 100, and make a new 'Output(neg)' column. Now, cross out 'Input(neg)' and write 'Output(gray)' above it. Also cross out 'Output(neg)' and write 'Input(gray)' above it. These paired Input(gray) and Output(gray) values are the values to be inserted into the GRAY CURVE function.

Numbers must be typed into GRAY CURVE following strict rules, so pay attention. First, be sure GRAY CURVE is turned on by deleting the # sign in front of it. Immediately following GRAY_CURVE = type a quotation mark. Then start at the bottom of the list of Input(gray)/Output(gray) values and enter them in sequence. You only need about eight to ten pairs of values. You must start with 0;0 and end with 100;100, even if the end points in your table are slightly different from those values. Type each pair exactly as shown, Input semicolon Output, with each pair separated by a space. Type another quotation mark after the final 100;100 pair.

Step 6: Test the New QTR Profile and Fine-Tune if Needed

Save the new profile, install it, use it to make a negative of the step tablet, make a print from the negative, scan the print, and make a table of Input/Output values from the scan measurements. If the Output values match the Input values within a percent or so, you are done. Congratulations! The QTR profile whose construction we used as an example, UCmk-Pict-4000-Pd, generated Output values that matched Input within 1% (probably within the error limit of this flatbed-scanner-as-densitometer process), except that from Input 97 to 100 all Outputs read as 99. We felt that small departure

from strict linearity would be lost in shadows anyway, broke out a bottle of beer, and declared victory.

If the new profile is good but not perfect at generating linearity, it may not be worth going back and tediously re-tuning the QTR profile. Instead, you might want to use the data from your final, good-but-not-quite-linear step tablet print to generate an .acv correction curve to be applied to the image file (exactly the same process we

Figure 10-5 A characteristic curve calculated from a print using our QTR Pd profile (red); and the corresponding .acv correction curve used to linearize this (black). Note that the correction curve used with the QTR profile is much less severe than the curves we created earlier with the QTR.

described in Chapter 7). As you will notice, some of the QTR profiles we provide on our Web site come with their companion .acv correction curves for that very purpose. We got close with the QTR profile and finished the job with an .acv curve.

QTR Profiles for Printers Using Different Inksets

You can probably make good digital negatives with any inkset, provided that (1) the ink will stick to the negative substrate you intend to use, and (2) the darkest ink can achieve a black sufficient to print white on the emulsion of your choice. QTR supports printing with a number of different inksets, but life is too short for us to test them all. Instead, we have concentrated on profiles for printers using the Epson Ultrachrome inks (models 2200, 4000, 7600, and 9600) and printers using the Epson K3 inkset (models 2400, 4800, and 7800). The Ultrachrome ink printers all print with seven inks, including two black inks (K and LK). For the K ink, either Photo Black or Matte Black seems to work, but be sure to use the type of black that was used during construction of the QTR profile. We expect that a QTR profile that prints a good palladium negative on one Ultrachrome ink printer will probably work, with only minor tweaking, on all the others.

The K3 ink printers print with eight inks at a time, including three blacks (K, LK, and LLK). For several reasons a QTR profile for an Ultrachrome printer will not work on a K3 printer without significant modification. Against expectation, K3 Photo Black prints only a dark gray on Pictorico OHP and is not useful. K3 Matte will print a dark black on OHP, but absorbs less UV light than its Ultrachrome counterpart. Only by setting INK LIMIT quite high (about 85) could we get sufficient density to print white on palladium. We were unable to linearize a palladium negative while using all three K3 black inks (K, LK, and LLK). LLK was the culprit and we finally just turned it off and then made fine negatives using only matte K and LK. We expect

that QTR profiles made for any member of the K3 family of printers will probably work reasonably will with the others.

Some Things that Can Go Wrong

In our experience the most common problem is that the Install Script refuses to install your newly modified QTR profile. If you look in the Profiles folder you will find a ReadMe file from Roy Harrington, which says that it is the title of the Install Script that determines which printer a given QTR profile will be installed into. Therefore, when you make a copy of the Install Script, after you drag it to its new location in the Install Script folder, delete the word 'copy.' QTR does not recognize the phrase '4000copy' as the name of any printer. We have found other finicky reasons why a profile will not install and there are probably more that we have not found. For example, the name of your modified profile must be a legal name (contains only letters, digits, underscore, or dash). It should have no spaces in it. If you have not put a 0 in front of fractional values for GRAY GAMMA the profile will not install. We have found some profiles with an active line of instructions such as PRINTER = Quad4000. If you want to install this profile into the 2400, you should probably change the name to Quad2400. Or perhaps you have not exactly followed the rules when typing Input/Output pairs into the GRAY_CURVE function. Be sure the printer is turned on and you are connected with a powered USB cable. And good luck.

Acknowledgments

This chapter could not have been written unless Roy Harrington had decided to develop and share the QuadTone RIP. In addition he taught us how to use the various

controls in QTR and specifically modified a profile to improve printing on Pictorico. He is also a great landscape photographer as you can see on his Web site (www. harrington.com).

PC Settings

The PC version of the QuadTone RIP is a stand-alone application that outputs your images to your printer. You will not access it in the same way as your existing Epson printer driver. The PC version has been made much easier to use through the addition of a graphical interface: QTRgui. This interface was created by Stephen Billard to simplify using the QuadTone RIP. Otherwise, the functionality of the PC version is the same as that of the Mac version. The PC version runs on all versions of Microsoft Windows XP and Windows 2000.

Downloading and Installing QTR (PC)

Go to the QuadTone RIP Overview Web site (www.quadtonerip.com) and on the left-hand side of the page, click Downloads. A new page appears where you can choose to download either the Windows or Mac version of QTR. Click the Windows download option, have Windows save the file to disk (by default Windows will save the file to your desktop, but you can place it somewhere more convenient). After the download has completed, find the install program and run it. Windows XP may display a security warning about this program (it does this for any program you download from the Internet). Click Run to run the QTR_Setup.

The QTR_Setup is a standard Windows setup wizard. It will ask you a few questions about the software license and the install directory. In our instructions we will

Figure 10-6 QTR Setup for PC.

Figure 10-7 Windows warning for Downloaded Programs

assume that you install the QTR program to the default location at C:\Program Files\QuadToneRIP. When the setup program asks about the components to install, make sure you install both the Printing Software and the Curve Creation Tools.

If you wish to print digital negatives you will need to install additional QTR profiles customized for each printing process you intend to use. Some custom QTR profiles are available on our Web site on the QuadToneRIP page. Download the QTR profiles for your printer model to your computer. The PC and Mac versions of these profiles are identical text files; but the PC files are identified as qidf files. Create a folder on your computer for these new profiles; we recommend creating a digital negatives folder in the C:\Program Files\QuadToneRIP folder. Move the QTR profiles to this folder; we will access these when we print the digital negatives. The QTR profile files also come with a

Figure 10-8 QTR setup wizard.

Readme file called 'About the <printer> Profile' for each profile. This file contains instructions on how to install the profile and the settings for QTR when using this profile. On the PC, the QTR profiles merely need to be moved to an appropriate folder to install them. These will be found under the folder C:\Program Files\QuadToneRIP\ Profiles. Copy each profile to the appropriate folder based on the Readme file.

QTR does not displace the normal Epson driver. Instead, QTR is a separate program that will send image files to your printer. Thus it is easy to switch between QTR (for high-quality black-and-white printing or digital negatives) and the Epson driver (for color printing) without changing the inkset.

And, do not forget to send Roy $50.

Printing a Digital Negative with QTR (PC)

The QTR prints via a stand-alone printer application: QTRgui. Run QTRgui from the QuadToneRIP program group that was created by the setup program.

Figure 10-9 QTRgui Main Screen.

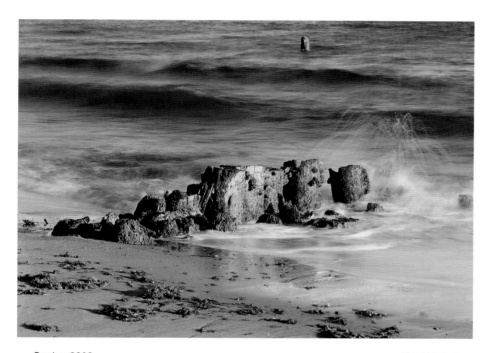

Supine 2002 Brad Hinkel

'This group of old log pilings reminds me of someone resting at the waterside and the splash of water creates an interested texture at the head. Interestingly, different viewers see and old or young person or even a dead body.'

Salt Print

I captured this image onto 4 × 5 TMax 100 film. The image was shot in bright sunlight so I had to add a number of filters to lengthen the exposure to more than one second. The long exposure helped capture the streaks of splashing water. I scanned the image into Photoshop and edited it to reduce some of the overall contrast and accentuate the splashed. A negative was printed onto Pictorico OHP film and contact printing onto a silver salt emulsion on Arches Platine paper. The salt print was toned using Selenium to add some additional density. The salt print provides the pink tones in the final print.

Final print size, about 8 × 10 inches.

You will need to save the prepared digital negative image to a file on your computer and access it from the QTRgui application to print it. Make sure that this image file has been inverted and flipped to create a negative as was outlined in Chapters 4 and 5. Instead of printing the digital negative from Photoshop, save it to a file. You

Figure 10-10 Photoshop Save As Dialog for TIF Files.

need to save these digital negative files as TIF files without Layers. Select File > Save As. Change the Format to 'TIF' and make sure that the Layers option is not checked. Click OK to save the file.

To print the digital negative, select the QTRgui application and select Image > Select Image to open the file you just saved from Photoshop. The specific settings in the QTRgui application will depend on the specific profile that you are using and need to match those described in the Readme file for the profile. Typically, this includes setting the Media Type, Resolution, Speed and the appropriate Curve for the profile. The profile for printing using the Epson 2200 on OHP for a Palladium requires the settings show in Figure 10-11.

Note the Media Type, Resolution, Speed and Curve for this profile.

Once the profile settings are correct, you merely press Print.

Editing a QTR Profile (PC)

The QTR profiles for the PC are identical to those described earlier for the Mac. But with the QTRgui application on the PC, the profiles can be more easily edited. In the QTRgui application, select the Curve Creation option on the menu to access the Curve Creator.

The Curve Creator provides the ability to easily access, edit and save curve profiles for QTR, rather than editing the text files as was described for the Mac. The same parameter values are available for Ink Limit, Gray Highlight, Gray Shadow, Gray Gamma and Gray Curve. These are all found on the Ink Setup and Gray Curve Tabs. Profiles can be opened, edited and saved from the File menu. Profiles should be found in C:\Program Files\QuadToneRIP\Profiles under the folder for your printer and ink. For most Epson printers this folder will include the model number for the printer and 'uc' for the Epson UltraChrome inks.

Otherwise, the options for curve creating and editing are identical on the PC as for the Mac described above. You can even create and edit the profile files using a text editor if you still like.

Figure 10-11 QTRgui Settings for Making a Palladium Negative on the Epson 2200.

Figure 10-12 QTRgui Curve Creator

Water and Ice 1998

Brad Hinkel

'Yellowstone park is often so cold that water can form over the top of streams as in this image. The snow had fallen during the day over the ice to create the final scene of water in the extreme cold.'

Cyanotype

The original image was captured onto 35 mm Velvia film in full color. A one second exposure created the texture of the moving water. The image was scanned into Photoshop and converted into a black & white image. A negative was printed onto Pictorico OHP film and contact printing onto a cyanotype emulsion onto fine art paper. The cyanotype worked ideally for the water scene.

Final print size, about 8 × 10 inches.

11 manipulatory miseries

We have a photography book, published in 1881, with a chapter that describes in detail how to coat, expose, and develop a collodion wet-plate negative. Following the how-to chapter is another, titled 'Manipulatory Miseries,' which lists the myriad things that can go wrong in the collodion process and how one might fix them. The age of collodion negatives is long gone, but every process, including the making of digital negatives, comes with its own list of 'manipulatory miseries.' This chapter describes the miseries we know about, how they might be abated, and some of the thinking behind the abatement procedures.

The major technical challenge in working with digital negatives is to produce a final print whose tones are as smooth and rich as they would be if made with a traditional wet darkroom negative. We know of three parts of the digital negative workflow in which smooth print tonality can be compromised: (1) problems can arise in the image file itself, when correction curves or other manipulations are applied to the file; (2) problems can arise if the printer head does not apply ink smoothly to the digital negative; and (3) objectionable grain can appear due to the chemistry of the sensitized emulsion (this problem is not unique to digital negatives).

Problems with the Image File

Problems at the level of the image file generally show up as posterization. This is a situation where smooth tonal gradients in the original image show up as abrupt, stair-stepped transitions in the final print. A few short years ago, posterization was a serious concern when working with digital negatives. Fortunately, if you use the tools described in this book, the problem can be essentially eliminated.

The first and most important step in preventing posterization is to start with an image that is either captured in 16-bit depth with a digital camera or scanned in 16-bit depth from a film negative and keep it in 16-bit depth as it is worked on in Photoshop®. Photoshop CS and later versions support 16-bit depth for nearly all image manipulations, which is the main reason you should avoid working with earlier versions of the program.

What is 16-bit depth and why is working in it essential? Early versions of Photoshop could only support working in 8-bit depth. In 8-bit depth, any pixel in an image can exist in one of 2^8 different shades of gray, which equals 256 different tones to cover the entire range from pure white to maximum black. If the 256 different tones are evenly distributed from white to black, they are sufficient to give the illusion of a completely smooth tonal gradient. Unfortunately, every time an image is manipulated in Photoshop, the tonal distribution is rearranged, bunching some tones together in one area and stretching out the tones in other areas. Applying a correction curve distorts the tonal distribution even more. The net result is that in some areas there are too few tones available to maintain the illusion of smoothness. Instead, the image posterizes with smooth tonal transitions replaced by ugly, blotchy stair-step transitions. Much of the posterization problem was eliminated when Photoshop CS came out and it became possible to keep an image in 16-bit depth from the time it was captured through the time it was printed. In 16-bit depth each pixel in the image can assume one of 65,536 different tones (2^{16}). This means

that the image can be manipulated, corrected, and rather severely distorted, and there will still be plenty of tones available to maintain the illusion of a smooth tonal gradient. Therefore, capture the image in 16-bit depth and never, ever drop it into 8-bit depth until it is sent to the printer.

When the image has been edited in 16-bit depth and looks good on the computer screen, you must decide at what point to apply the necessary corrections so that tonal values on the computer translate accurately to tones in the final print. You have two choices: the corrections can be applied to the image file itself, or they can be tucked down into the printer driver. Application of the correction curve to the image file often severely distorts the file. In the old days of 8-bit files, this much distortion would have inevitably led to posterization. Amazingly, a 16-bit file can handle a severe correction curve without visible damage to the image histogram. Even so, we still recommend learning how to put the correction curve into the printer driver, using a powerful driver such QuadTone RIP as described in Chapter 10. Learning how to modify a printer driver does require learning another dose of computer wizardry, but it gives you much more control when fine-tuning the subtle high tones of a print. And it would seem to completely eliminate any chance of posterization. It is also our impression that the high print tones just 'look better' when the correction curve is placed in the driver. We admit we cannot produce an objective experiment to back up that subjective impression.

Figure 11-1 illustrates graphically why you want to work on the image in 16-bit depth. The top image shows the histogram of an image created in 8-bit depth and never manipulated (to see the histogram of an image, go to Image > Adjustments > Levels). The histogram is smooth and not gapped. The lower left image shows the histogram of the same image after a typical adjustment has been applied. The tones have been shifted, there are gaps where the computer has to guess what tones to fill in, and this image will definitely be posterized in some areas. The image on the lower

Original Image & Histogram

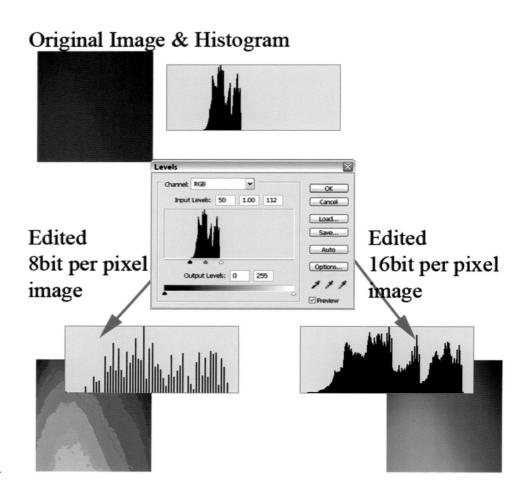

Edited
8bit per pixel
image

Edited
16bit per pixel
image

Figure 11-1 8-bit vs 16-bit.

right shows the histogram of the same image after application of the same adjustment, except this time the image was created in 16-bit depth. Application of the correction curve can lead to dramatic adjustments and needs the 16-bit images to prevent posterization.

As you send the image to the printer, regardless of where you decide to apply the correction curve, you will want to choose No Color Management in the Print with Preview window. Color management consists of correction curves, applied by either Photoshop or the printer, which further distort the image file. Direct experiment has shown that a smoother tonal gradient will print on the negative when No Color Management is selected, perhaps because these additional correction curves are applied after your 16-bit file has been dropped to 8-bit depth in preparation for print-ing. (Remember, printers only print 256 different tones, which means they operate in 8-bit depth.)

That about does it for problems arising in the image file. If you take all these pre-cautions — capture and work in 16-bit depth, put correction curves in the driver, and print with No Color Management – then posterization problems should be a thing of the past.

Printer Drivers

We will now talk a bit about printer drivers and media type settings. If you use an Epson printer driver to print your digital negative, you will have to select a Media Type in the Print window (under Copies and Pages, scroll down to Print Settings and you will see a window titled Media Type). Each media type is a group of presets that adjusts the maximum amount of ink deposition and linearizes midtone ink deposition for a particular type of printing surface. In essence the Epson media type settings are the same as the various QTR profiles that can be installed in the QuadTone RIP.

Unfortunately, the Epson presets are not ideal for digital negative printing because these presets must control all seven inks for color printing (instead of just the two blacks needed for negatives) and cannot be altered. Therefore, none of the Epson presets are very close to what we need for a digital negative. Another curious problem with the Epson media type presets is how they behave when No Color Management is selected (remember, we want that setting for the smoothest possible tones). On the Epson 4000, with No Color Management, most of the media type settings will not print a good grayscale. Instead, at some point in the grayscale gradient the tones will invert. On other Epson printers (such as the 2200) this problem is less severe, but often the grayscale will have flat patches where there is no change in tonal value. We suspect that this problem arises because the Epson driver uses a combination of several inks to print gray tones, and the dark tones are printed by a set of inks different from the light tones. At crossover points where the driver switches from one combination to another, inversions can occur.

So, what to do? It is difficult to see how to make an image correction curve that will accurately correct an inversion in the grayscale. For those who want to use a premade correction curve, we have made correction curves paired with media settings that are less subject to this problem. They actually work pretty well. It is possible, if you want to use Epson drivers, you would be better off to leave Printer Color Management turned on when printing. Then select some media type like Glossy Photo Paper and make a custom correction curve for those conditions. This might give you a bit less smooth tone, but would probably solve the grayscale inversion problem. The ultimate solution is to abandon the Epson drivers altogether and learn how to use QuadTone RIP; even with No Color Management it prints a nice, noninverted grayscale with a basic paper profile (i.e., media type) such as Epson Enhanced Matte. A correction curve would still need to be derived for image application or you could go all the way, learn to put the correction curves in the driver by making custom QuadTone RIP profiles, and avoid the entire question.

Printing Negatives in Colors Other Than Black and White

If you print a grayscale with an Epson driver and No Color Management, you will notice that the scale is not entirely shades of gray. At the dark end of the scale it is mostly composed of black ink, but as it goes to lighter tones it becomes markedly green. Apparently this is because the Epson printer driver is designed to generate many of the middle grays from combinations of colored inks other than black. In general we do not care, as long as the gradient of black and greenish tones prints as a smooth tonal gradient on the emulsion of our choice. In fact, any color can be used to make a digital negative as long as it generates a smooth tonal gradient and is dense enough to print pure white at one end of the gradient.

Some workers prefer to print their negatives in shades of green or some other color. As we understand it, the main advantage of colored negatives stems from the fact that the RGB colors (red, green, and blue) have varying opacities to UV light. By judiciously choosing a combination of these colors, you can print a negative in which the color of 100% 'black' has just enough UV opacity to print as pure white on the emulsion of your choice. This is, in effect, another method to adjust the contrast range of a negative to exactly match the contrast range of a particular emulsion. Adjusting negative contrast in this way has two potential benefits. First, the correction curve used to make this type of negative can be less extreme since it only has to adjust midtone values and does not have to do the additional work of adjusting the black and white end points. Second, if your image is in 8-bit depth, adjusting negative contrast range to emulsion contrast range means that the entire set of 256 image tones can be used to make midtones with very few lumped together in paper white or maximum black. This should maximize the chance of obtaining smooth tonality in the final image. Using color to adjust the contrast of a digital negative is an elegant idea, and those who wish to explore it more should go to Mark Nelson's Web site (precisiondigitalnegatives.com) and purchase his CD, on which he describes the method in great detail.

Now that QuadTone RIP is available, we feel it makes more sense to adjust the contrast range of the negative by controlling Ink Limit Adjust in the QuadTone RIP driver. With a little more work one can also linearize the midtones by changes to the QuadTone RIP driver and avoid nearly any distortion of the image file.

Sharpness

Digital negatives can produce prints that look quite sharp and, paradoxically, the apparent sharpness will increase as print size increases. This is because a large digital image is just as sharp as a small digital image since there is no optical degradation of the image with digital enlargement. Yet, the optimal viewing distance increases as print size increases and thus the larger print looks sharper than the small print.

A major source of fuzziness in prints is failure to keep the digital negative in tight contact with the sensitive emulsion when exposing the print. For print sizes up to about 8 × 10 inches, a simple contact printing frame, or even a sheet of heavy glass, is usually sufficient to ensure good contact. For larger prints, however, the best choice by far is a vacuum bed that sucks negative and emulsion into tight contact.

Printer Banding

Unless the speed of the print head is precisely co-ordinated with movement of the media being printed on, the negative and the final print will contain alternate light and dark bands. In many images, a small amount of banding gets lost in image detail. But it can be devastating in smooth tonal areas like a light gray sky. Newer Epson drivers have controls that allow one to change media feed rate in small increments to combat banding.

Unfortunately, current versions of QuadTone RIP do not have this feature. We look forward to the day when printer hardware and software will combine to eliminate this problem.

Graininess

All photographic images are ultimately composed of discrete dots: pixels on a computer screen, dots of printer ink, or clumps of reduced metal. Ordinarily we try to minimize dot size, or graininess, in the final print because it interferes with the illusion of smooth tonality.

Inkjet printers can introduce unwanted grain when printing a digital negative. Epson inkjet printers print at a resolution of 360 ppi. However, you usually have the option of telling the printer how many dots of ink are used to print each pixel. Thus, if you set the printer to print at 2880 dpi, the printer will use 2880/360 = 8 tiny dots of ink to specify each pixel. Generally, in printing digital negatives, the more dots per inch you can get the printer to lay down, the better. How visible the dot structure will be depends on the media being printed on: on a matte paper, the dot structure of a 1440-dpi image will practically disappear even when viewed under a magnifying loupe. Unfortunately, when printed on Pictorico OHP, the dot structure will be readily visible. The plastic base of OHP has a special coating that allows Epson Ultrachrome inks to adhere, and this coating seems to cause the ink to clump a bit and enhances each individual dot. Whether or not this is a problem again depends on the type of print the negative will be used to make. If the negative is used to make a palladium print on matte surfaced art paper, chances are the printer dot structure will nearly be lost in the matte surface. If, however, an OHP negative is used to print on glossy silver/gelatin paper, the dot structure will probably be objectionably visible. This is one area where

we hope printers and printing media will continue to improve in the coming years and make the problem go away. For the present, however, we suggest the following workarounds. First, tune your printer so it is doing the best job it can. This means making sure the print heads are clean and properly aligned. In some printer drivers you can choose between different dither patterns or dot structure. Experiment, since some dither patterns may give smoother results than others. Fortunately, in many printing procedures digital negatives are used to print on matte finished papers, and the dot structure of an OHP negative pretty much disappears in the paper surface. For printing on silver/gelatin paper we recommend printing the digital negative on glossy white film. Inkjet printers print more smoothly on glossy white film and the film is sufficiently transparent to white light that it can be used for silver/gelatin printing. Unfortunately, the brighteners that are added to make the film super white also absorb UV light and glossy white film is not useful for printing methods that use UV light.

In platinum/palladium printing, a common cause of graininess in the final print is the addition of contrast agents to the sensitized emulsion. Back in the days when all platinum/palladium printing was done with negatives produced in the wet darkroom, it would often occur that a large, laboriously produced negative would not have exactly the correct contrast range. Rather than go back and remake the negative, it was common practice to fine-tune the contrast of the emulsion to fit the range of the negative in hand. For nearly a century the most commonly used contrasting agent was potassium chlorate. Chlorate readily increases the contrast of platinum/palladium emulsions, but it has two negative effects as well. It lowers printing speed and the reduced metal tends to clump together in visible grains. More recently, Richard Sullivan re-introduced the use of disodium chloroplatinate as a contrast agent (often abbreviated as Na_2). Compared to chlorate, Na_2 is a superior contrasting agent. Addition of small amounts significantly increases contrast with little, if any, reduction in printing speed. If you wish to fine-tune the contrast of a platinum/palladium emulsion, Na_2 is an excellent tool and most printers will want a bottle of it on their reagent shelf. However, in our experiments with Na_2 we

definitely see an increase in graininess, even though it is less grain-inducing than chlorate. Therefore, in order to achieve the smoothest tones possible, we prefer to print with an emulsion that contains only palladium and ferric oxalate sensitizer. One of the pleasures of working with digital negatives is that, with an accurately made correction curve, it is relatively easy to adjust negative contrast to emulsion contrast and leave contrasting agents out of the emulsion itself.

Irises in a simple glass vase against a backdrop which is an enlarged photo of other irises.

Taken on Kodak Tmax 100 film with a Linhof Technikardan 4 × 5 view camera and scanned with an Epson 1680 flat bed scanner. The image file was converted to RGB mode and the Hue/Saturation/Colorize tool in Photoshop was used to make snapshots of the image in various desired colors. The history brush was then used to paint each of the colors in its desired location against an overall black and white background. The image file was then converted to CMYK mode and the color channels (CMY) were printed onto a sheet of Arches Platine using the Epson 2200 printer. The printed paper was then coated with sensitized palladium emulsion and set aside to dry. The black (K) channel was converted to grayscale mode, a correction curve was applied, and the image was inverted and printed as a negative on Pictorico OHP. The digital negative was then registered on the previously coated paper, exposed to UV light, and processed.

Final print size, about 8 × 10 inches.

Irises in a Vase 2003 Ron Reeder

12 adding color to a
platinum/palladium print

Throughout the history of platinum/palladium printing, photographers have tried several strategies to introduce color into what is basically a black-and-white image. One successful approach has been to overprint the platinum/palladium image with one or more layers of colored gum, exposing each gum layer through a separation negative specific for that color. With care and much labor, printing gum over platinum/palladium can reconstitute a reasonably accurate full-color image. A major part of the labor in making gum-over-platinum/palladium prints is in generating accurate full-color separation negatives for each layer of gum printing, and digital processes can greatly speed up that part of the work.

An easier way to put color into platinum/palladium prints is to skip the gum layers and use a digital printer to print colored inks directly onto the paper. In this approach, a color image is resolved into its color component and its black-and-white component. The color component is printed onto a piece of art paper, and then the black-and-white component is inverted to make a digital negative to overprint the color with platinum/palladium. In our experience, combining digital color with platinum/palladium is a highly flexible approach to printmaking. The final product can be photo-realistic, mimic hand-tinted photographs, or look like a Polaroid® image transfer. Best of all, once you know the basics of making digital negatives, adding digital color is relatively simple to do.

Dan Burkholder was one of the first to show images combining digital color with platinum/palladium printing. However, the method we describe in this chapter was

developed independently and cannot be blamed on anyone but ourselves. For brevity, we will refer to the process as pigmented platinum.

Colorizing a Black-and-White Image

Any color image can be used to make a pigmented platinum print. Our preference is to begin with a black-and-white negative (usually made with a 4×5 view camera), scan it into Photoshop®, invert it to a positive, and then add color manually. We like the emotional impact of artificial color applied when and where we want it.

There are several ways to colorize an image in Photoshop, but we find the Colorize option on the Hue/Saturation window plus the History Brush to be the most versatile approach, and use it almost exclusively. The process goes like this:

- Begin by resizing the image to the dimensions desired for the final print. Since we save our original scans at the maximum resolution our scanner can produce, resizing usually decreases the file size and makes all subsequent steps go faster. For purposes of this illustration, we assume the final image will be 8×10 inches and will be printed on an 11×14-inch sheet of paper. Go to Image > Image Size, change the image size to 8×10 inches, and set Resolution to 360 ppi (this is the resolution at which the Epson 2200 prints, regardless of where image resolution is set).
- Convert the resized grayscale image to RGB mode (Image > Mode > RGB).
- Open the Hue/Saturation window (Image > Adjust > Hue/Saturation).
- Click the Colorize box. The entire image will immediately turn some shade of reddish brown.
- Move the Hue, Saturation, and Lightness sliders around until you have created a color that you want to use somewhere in the image (Figure 12-1).

Figure 12-1 The Hue/Saturation window has been set to Colorize and the sliders have been moved to create a shade of blue.

To save this color state, open the History window (Window > History) and click the Snapshot icon at the bottom. This action will cause a snapshot of the chosen color state to appear as a bar at the top of the History window.

Open the Hue/Saturation window and repeat the process again, creating a new desired color, and saving this second color as another snapshot. Repeat the process of creating new colors and making snapshots of them until all the colors you wish to use in the image have been created and saved.

After snapshots of all desired colors have been created, open the Hue/Saturation window once again, grab the saturation slider, and shove it all the way to the left. This will take all color out of the image and leave you with a grayscale image on which to paint the colors that have been created. Take one more snapshot of this colorless image.

- To apply one of the snapshot colors to the image, click the bar for the grayscale snapshot. The image will lose all color. Now, assign the History Brush to a desired color snapshot (click the box to the left of the snapshot). Then, in the Tools palette, click the History Brush tool and choose a size for it. Finally, move the cursor for the History Brush over your grayscale image while holding the mouse down and selectively paint the snapshot color onto the image (Figure 12-2).

Figure 12-2 Painting with the History Brush.

- To apply a second snapshot color, assign the History Brush to that color and paint some more. Continue until the image is colorized as you wish.

- Save the colorized image as 'imagename-color.'

Some additional thoughts on colorization:

- We often want the entire image to have a light sepia tone with other colors laid onto this background. Rather than laboriously paint the entire background in sepia, create a sepia snapshot (Hue 36, Saturation 8, Lightness 0 makes a nice sepia) along with all the other desired color snapshots. Then, at the beginning of the painting process, click on the sepia snapshot itself (rather than on the grayscale snapshot). The entire image will turn sepia. Then assign the History Brush to some other color and paint onto the sepia-toned image.

- You can change the opacity of the History Brush tool. We usually set it at some low value, perhaps around 20%, and then build up color in multiple passes of the brush. This approach gives more flexibility in achieving exactly the right color density and can allow an uneven distribution of tone that is often more pleasing than a uniform application.

- The grayscale snapshot is useful if you want to erase color from some part of the image. Assign the History Brush to the grayscale snapshot, lower the opacity of the History Brush to 10–20%, and use the brush to decrease color saturation in any area that seems overpainted and garish.

- Be aware that the History Brush can only paint a snapshot color back onto the layer from which it was created. For this reason you should flatten the image into a single layer before beginning the colorization process.

Making a Color Separation

The pigmented platinum process requires separating the colorized image into two files, one containing the color information and a separate file containing the black-and-white information. To prepare for making these separations, open the Color Settings window (see Figure 12-3; in Mac Photoshop CS2, this window is found under File > Color Settings).

- In the Color Settings window, go to the CMYK drop box in the Working Spaces group box and select 'Custom' from the drop list to open the Custom CMYK window. In the Separation Options group box, go to the Black Generation drop box and choose 'Maximum' from the drop list (Figure 12-4).

- While you have the Color Settings window open, you should also define a few other settings. Click the Advanced Mode check box. In the Working Spaces group box, choose 'ColorMatch RGB' from the RGB drop list for color and choose 'Gray Gamma 1.8' from the Gray drop list. In the Color Management Policies group box, choose 'Convert to working RBG' from the RGB drop list, and choose 'Convert to working gray' from the Gray drop list. In the Conversion Options group box, choose 'Colorsync' as the Engine and 'Perceptual' as the Intent.

These settings allow a rudimentary type of management in which you will select various Epson paper profiles before you print. These profiles will not exactly match the media on which you are printing, but, in our experience, come close enough for the pigmented platinum process to work well.

Close all the color settings windows.

Now, open your colorized RGB image (the 'imagename-color' file) and convert it to CMYK mode (Image > Mode > CMYK color). Open the Layers window

Figure 12-3 Photoshop color settings,
preliminary to making CMYK separations.

(Window > Layers) and click the Channels tab at the top of the window to display
the four CMYK channels that now make up the image. Turn off the K (black) chan-
nel by clicking the box to the left. You will see that the remaining C, M, and Y chan-
nels contain only color information. Conversely, you can turn off the C, M, and Y

Figure 12-4 Custom CMYK settings.

channels and see that the K channel has all the black information. These are the separations that you want for the pigmented platinum process (Figures 12-5 and 12-6).

To summarize the separation process:

- Convert image to CMYK mode (Image > Mode > CMYK).
- Open the Layers window (Window > Layers) and click the Channels tab.
- Grab the K channel and drag it to the trash, leaving the CMY channels.
- Convert the image back to RGB mode (Image > Mode > RGB color).
- Choose the Pencil tool, select a brush width of about 5 pixels, and make sure that black is chosen as the foreground color. Then carefully draw right-angle registration

Figure 12-5 Color channels separation window.

marks at the extreme corners of the separation image. These marks will be useful when placing a contact negative in register over the separation image.

- Save the file as 'imagename-separation.'

Note that in these operations, after discarding the K channel, the remaining CMY channels were converted back to RGB mode. This is done to achieve brighter, more vibrant colors in the final print. Converting from CMY back to RGB means that Photoshop has to guess about some colors as it moves from the smaller gamut of CMY to a larger gamut of RGB. The result is that the colors in the RGB-converted separation will become a bit garish and overbright. If we were trying for highly realistic, natural colors in the final print, this would be a problem. Fortunately, however, the overbrightened colors seem to compensate for the dulling effect of overprinting with platinum/palladium. The end result is usually an acceptable compromise. If desired,

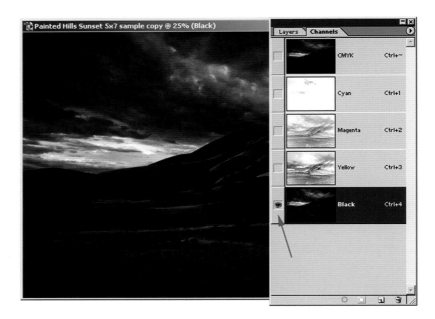

Figure 12-6 Black channel separation window.

you could skip the CMY to RGB conversion and print the CMY separation directly (hold down the Shift key and select all three channels before printing, otherwise you will print only one channel). This will produce more muted colors, which might be appropriate for some prints.

Printing the Color Separation

- Open the 'imagename-separation' file.
- Open Page Setup (File > Page Setup), select printer (Epson 2200), paper size (11 × 14 inches), and image orientation (portrait vs landscape). Close the window.

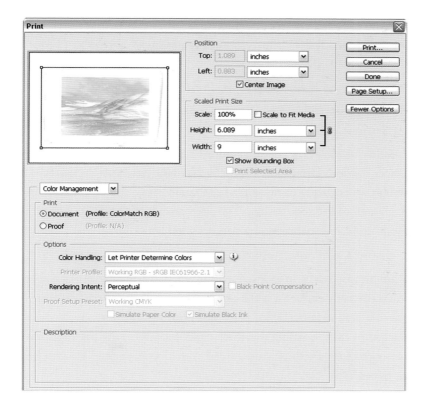

Figure 12-7 Print window for the color plate.

- Go to File > Print with Preview. You should immediately see a large thumbnail of your separation image properly positioned within an 11 × 14-inch space. If it is positioned wrongly, go back and check the Page Setup settings (Figure 12-7).

- You may need to press the button labeled "Show More Options" at the lower right of the dialog to see these options. In the drop box, select 'Color Management' from the drop list, and select Document in the Print group box. It should display 'Profile: ColorMatch RGB' since that is the color space you chose to convert

everything to when you made the color settings mentioned earlier. Go to Print Space > Profile, choose 'Printer Color Management'; go to Print Space > Intent and choose 'Perceptual.'

- Now go to the top right corner of the Print with Preview window and click Print.

- Another window will appear. Under Copies and Pages, scroll down and choose 'Print Settings.'

- Yet another window will appear (Figure 12.8; don't give up, we're getting close). In the Paper Options group box, choose 'Velvet Fine Art Paper' in the Type drop box. Although we normally print on Arches Platine paper, the Velvet Fine Art profile is close enough to get good results. The alternative is to develop a custom profile for Arches Platine and we have not yet seen a good reason to do that.

- Also choose 'Color' ink, 'Automatic' mode, and 'Quality' speed.

- You are almost ready to print. Load an 11 × 14-inch sheet of paper into the Epson 2200 printer. As we said before, we normally use Arches Platine because it was formulated specifically for platinum printing and works well with the Epson Ultrachrome inks. Loading this thick paper requires using the alternative loading slot reserved for very thick stock. Read your Epson manual to learn how to load thick paper.

- Click Print.

Making a Full-Size Contact Negative

- Open the 'imagename-color' file and convert to CMYK mode. This time drag the CMY channels to the trash, leaving only the K channel.

- Convert the file from multichannel to grayscale mode (Image > Mode > Grayscale).

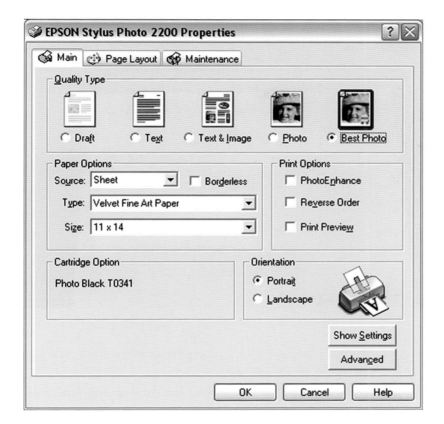

Figure 12-8 Set the printer driver (EPSON Stylus C86 Series Properties window shown) to print the best photo quality.

From here on, the procedure is exactly the same as was described in Chapter 5 for making a negative for palladium printing. Flip the image horizontally, apply a correction curve appropriate to the platinum/palladium mixture you will use, invert the image to a negative, and save it as 'imagename-neg.' Then print the negative on a piece of Pictorico OHP.

Figure 12-9 Photo of platinum coating over the color print.

We can use a palladium curve for a pure palladium emulsion; this produces a 'black' plate, which warms the overall image.

Print the platinum/palladium image onto the color image. Spread sensitized platinum/palladium emulsion directly over the color image, using the corner register marks if necessary to guide the spreading. After drying, use the register marks again to accurately place the negative, expose the sandwich to UV light, and develop as normal, and then clear, wash, and dry the print (Figure 12-9).

We have noticed one complication when printing platinum/palladium over Epson Ultrachrome inks. On occasion, some of the inks, especially magenta, seem to act like a wick, drawing the sensitized emulsion deeply into the paper. When this happens it is difficult to completely clear the developed print. From the front the image

will look normal, but from the back a tan stain will be present wherever certain inks were printed. The severity of the problem varies between batches of Arches Platine paper, suggesting that it is related to variations in sizing of the paper. Current paper batches do not exhibit the problem. One solution to the problem is to print the platinum/palladium image first, clear and dry the paper, and then print the color image over the platinum/palladium image. This method produces fine images, but we have not used it very much due to the added difficulty of registering the color and platinum/palladium images.

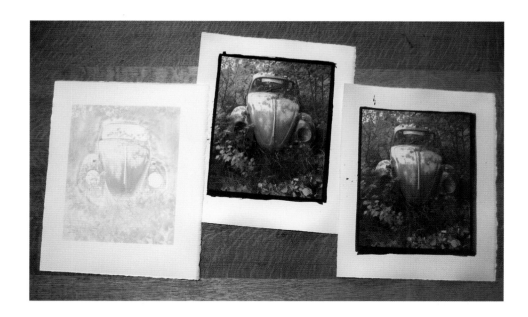

Figure 12-10 Three stages of printing Platinum & Color – the color inkjet print without any black; the black print without color; and a print with the color combined with platinum.

resources for alternative process

Suppliers

Bostick & Sullivan
PO Box 16639
Santa Fe, NM 57506
USA
www.bostick-sullivan.com
tel: 505-474-0890

Bostick & Sullivan is our primary source for alternative process chemicals as well as accessories for printing. Ordering online from the Bostick & Sullivan website is easy or you can call if you have specific questions about supplies. They have access to almost any chemicals necessary for most alternative processes and the knowledge on how to use them, plus they have excellent contact printing frames.

Photographers' Formulary
PO Box 950
Condon, MT 59826
USA
www.photoformulary.com
tel: 406-754-2891

Photographers' Formulary is an excellent chemical and equipment supplier for alternative processes. The various alt process kits from Photographers' Formulary are a good way to experiment with a new technique. Plus they offer a series of weeklong workshop on alt process techniques at their facilities in Condon Montana every summer.

Daniel Smith
4150 First Avenue South
PO Box 84268
Seattle, WA 98124
USA
www.danielsmith.com
tel: 206-223-9599

Daniel Smith is an excellent source for paper and other traditional art supplies. This is a great resource for experimenting with new papers (and there are hundreds of beautiful papers) and tools for mixed media. Ordering directly from danielsmith.com is easy. Being local, this is a fun location for us to go and just browse through new options for printing.

New York Central Art Supply
62 3rd Ave @ 11th Street
New York, NY 10003
USA
www.nycentralart.com
tel: 212-473-7705

New York Central Art Supply has been repeatedly reported to me as 'the greatest art store ever'. The supply any and all needs for artist in New York City. Go online and take a look through their catalog, or better go take a look at the store in NYC.

John Purcell Paper
15 Rumsey Road
London, SW9 0TR
UK
www.johnpurcell.net
tel: 44 (0)20 7737 5199

John Purcell is one of the largest supplies of papers in Europe. They provide papers from the great paper mills of Europe plus import papers from around the world. I have been told that 'if it is paper, they have it.'

SilverPrint Ltd
12 Valentine Place
London, SE1 8QH
UK
www.silverprint.co.uk
tel: 44 (0)20 7620 0844

SilverPrint is the leading supplier of photo chemicals and chemicals for alternative processes in the UK. Their catalog includes alt process kits, papers and chemicals. They also carry Pictorico film.

Pictorico USA
c/o AGC Chemicals Americas, Inc
229 East 22nd Street
Bayonne, NJ 07002
USA
www.pictorico.com
tel: 888-879-8592

This is the easiest source for Pictorico film (although you may find it locally).

Blueprintables
PO Box 13066
Vashon Island, WA 98013
USA
www.blueprintables.com
tel: 800-894-9410

A source for manufactured cyanotype papers and fabrics.

Smith/Chamlee Photography
PO Box 400
Ottsville, PA 18942
USA
www.michaelandpaula.com/mp/azo_main.html
tel: 610-847-2005

The source for AZO silver paper; a premier quality silver paper for contact printing

Chicago Albumen Works
PO Box 805
174 Front St
Housatonic, MA 01236
www.albumenworks.com
tel: 413-274-6901

The source for Centennial Printing-Out Paper; a gelatine silver paper for contact printing. Full instructions on printing with Centennial paper are available on their website.

Edwards Engineering Products
'a few miles north of Austin in the Texas Hill Country'
www.eepjon.com
tel: 512-267-4274

Jon provides detailed instructions for making your own exposure light source; and then sells completed light sources and vacuum frames for those who want to buy the completed product.

Web Resources

www.quadtonerip.com
The source for Roy Harrington's Quadtone RIP. A great tool for advanced digital negative printing; and a great RIP for printing black & white images on Epson inkjet printers.

www.unblinkingeye.com
A website full of useful articles about the full range of alternative processes. It includes some interesting articles about specific tools as well – such as light sources.

www.alternativephotography.com
A site containing galleries, book reviews, articles and technical instructions for alternative processes. The galleries are an excellent resource to see a full range of beautiful alternative process images.

www.digital-negatives.com
Our site that supports the content of this book. This site contains the files covered in this book, new articles from our research, links to web resources and instructions on teaching digital negatives. It might also contain errata for this book eventually as well…

index